Mrs. Nussbaum's Monkey takes us into a Pittsburgh that's gone but will never go away, a place of bridges and stairs and tugboats, Skookum Field and the Iron City sign, where people and animals that share their space negotiate daily to survive, and to survive themselves. With E. E. Cummings' inversion of language and a clear eye for the "beauty and indignity," Frank Lehner demands that we see anew. This book of hours has space for legend, for angry husbands and practical saints and stolen dogs and old soldiers "trying to make sense of their stiff legs," men broken by war and work whose ghosts can't quit Pittsburgh any more than the living can. But grace awaits. We try to speak into the stone ear of God, when what we need is what our fathers taught us: "...the oiled glove, the small garden, / the clean tool, and sitting on a dock without a sound, watching a bobber."
—Valerie Nieman, author of *Upon the Corner of the Moon*

In his first full-length collection, Frank Lehner delivers a lifetime of earned wisdom, humility, and grace, taking us on pilgrimages to holy sites where we meet his beautiful, flawed saints. The poems resonate with the pulsing rhythms of Pittsburgh, the city he unabashedly loves. He finds the sacred in all small living things—insects, birds, flowers, animals. There's a stillness here in which transformations take place, a kindness which allows our shared humanity to be recognized and celebrated. Through litany and urban legend, through incantations and prayer, Lehner lifts us into a spiritual world where the potential for totems is everywhere. Every penny found is a jewel with its own story to tell. Lehner doesn't imbue these totems with magic—he recognizes and pays tribute to the magic they already have: "The bumble bee on my forearm offers a powdery gold tattoo of her journey."
—Jim Daniels, author of *Blessing the House*

Other Books by Frank Lehner

Chapbook:
Some Kingdom, GTA Press.

Plays:
Four for Cheese was staged by the Pittsburgh New Works Festival and was published in the literary periodical *Janus Head*.
I Sleep with My Books and *Cactus Finger* were staged by the Synchronicity Theater Group, NYC.

Bottom Dog Press
Huron, Ohio

MRS. NUSSBAUM'S MONKEY

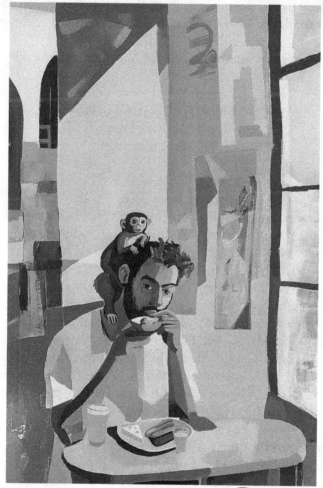

FRANK LEHNER

Bottom Dog Press
Working Lives Series

Copyright © 2025
Bottom Dog Press & Frank Lehner
All rights reserved.
This book, or parts thereof, may not be reproduced in any form without permission from the publisher; exceptions are made for brief excerpts used in published reviews.
ISBN: 978-1-947504-48-6
Library of Congress Control Number: 2025936388

Bottom Dog Press, Inc.
PO Box 425, Huron, OH 44839
Lsmithdog@aol.com
http://smithdocs.net

CREDITS:
General Editor: Larry Smith
Cover & Layout Design: Susanna Sharp-Schwacke
Cover Art & Section Artwork: Craig Seder, *Two Men*

ACKNOWLEDGMENTS:
This book has been a long time coming. That's how life has its way. But here, now, allow me to acknowledge a handful of folks who helped to carry and guide or supported me in the making of this work: Mr. Albert Hamel, Patrick Ames, John Hamlin, Frank O'Hara, Gerald Stern, Kevin Rippin, Judith Vollmer, Timothy Russell, Valerie Nieman, John Repp, Lynn Emanuel, Jim Daniels, Ed Ochester, Peter Oresick, Mark Symczak, Michael O'Connor, Phyllis Sigal, Craig Seder. (If I've forgotten you, it's not on purpose—just tell me I'm a "jagoff" when you see me.) I am profoundly grateful to Larry Smith and Susanna Sharp-Schwacke at Bottom Dog Press for believing this work worthy of their imprint and your eyes. This book is impossible without Pittsburgh, my dwelling. And, lastly, without whom I would be not this, my wife and my wonderful tangle, Nancy Koerbel.

Contents

Lectio Divina ... 9

This Wet Life
I'm Waiting ... 13
This Wet Life ... 14
The Tomatoes Stay Green .. 15
Where the Wrought Iron Rail Curls 16
To Come Unsatisfy ... 17
We Two Prayed ... 18
Small Bites ... 19
Some Story ... 20
Not Neglecting the Cardinal ... 21

All the Wrong Things
All The Wrong Things ... 25
Grave Fingers ... 26
Did You Get Healed? .. 28
Thin Silence ... 29
Cave Tease ... 31
There Grows the Saving .. 33
As God as Anything .. 34
It Slid Slowly By .. 35
Labor Day 2024 ... 37
As Though It Were Not Yet .. 39
Small Picnic ... 40

Our Prophesies
Miss Addy ... 43
Our Prophesies .. 44
Seven Years Ago Yesterday ... 46
We Are Separated by the Thinnest Filament 47
Shit Prayers ... 49
Dick Teddy ... 50
Swallowing Death .. 52
To the Shape of Desire ... 54
Not Giving Up ... 55

Joyous Pain
Venus .. 59
Too Much ... 60

Joyous Pain	61
What He Gave Me	63
Between Language and Jouissance	65
All That Forward	67
Tulip Continued to Blush	68
She My Eye Blue	69
This Moment of Fruit	70
See Right	71

Nothing in Heaven

The Aluminum Awning	75
All Get Wet	76
April 5, 2020 Palm Sunday	77
Imprisoned Hearts	78
To Hang and Home	80
No Saint Will Relieve Me	81
For Naught	82
First Day of Spring	83
It's Gonna Take a Miracle	84
Coffee and Christ	85
The Particulars of Rapture	86
By the Hand of My Tongue	87
From the Grave to Touch Again	88

Mrs. Nussbaum's Monkey

Our Parade	91
In Pittsburghia	92
Mirabile Dictu	93
It's Like Giving Directions in Pittsburgh	94
Canvas Flaps	95
Not to Know	96
Treats We Shared	97
Penny's Testament	98
Confession	99
In the Time When Nothing Is Said	100
Draft Letter to Nancy Koerbel's Poetry Class	101
Clay and Bricks	103
Mrs. Nussbaum's Monkey	105
It Made Me Cry	107
Notes	109
About the Author	113

In Pittsburgh, beautiful filthy Pittsburgh, home
—Gerald Stern

She's got Yinzer Cred.
—Nancy Koerbel

Lectio Divina

World has become screaming green.

Giddy flower turns petals to hands.

Breeze loops ear and chin with kisses.

Hummingbird snapshot-still then not.

Squirrel lies and chews with the crow.

We've just set out the porch furniture.

Sister, here's a chair, coffee, and a sweet.

THIS WET LIFE

I'm Waiting

Here I am, again, up, staring out my window.
I don't know what I expect as I sit, broken
oak chair creaking, my bare toes clutched
tight on the carved claws, the dog somewhere
but not here. I am waiting in the half-light
for a sign. I am waiting in the Sunday quiet
before the leaf blowers and lawnmowers
ruin everything. My back still a bit sweaty
from sleep, my cheeks a bit morning itchy.
I'm waiting for the birds to begin. I'm waiting
for the damp breeze to show me the way.
I'm waiting for the daisies to dance.
I'm waiting for my first friend the squirrel
to chirp and click and scamper up my leg
tear around my trunk and plotz flat over my head,
his twenty-two teeth clattering joy, his nose puffing,
his mad heart pounding a million nows an hour.
I'm waiting for more than I deserve to want.

This Wet Life

Dawn washes light the night face
of this simple landscape holding me.
It is so quiet, the breeze has yet to wake.
The lilac's sweet prayers wait for her bees
to nuzzle and kneel in her sticky wonder.
A rooster has raised his head and claims
the day to begin and windows click bright
all around me while the tug's plaintive horn
rolls from the river over the hill, and now
the blanket left by last night's fever rain
unthreads as puddles and jewels the leaves wear.
This to awaken to my love in this wet life here.

The Tomatoes Stay Green

The dappled willow struggles hard, open
scarred from the gouge and tear the rut buck inflicted.
I have spoken to her. I have twisted her shoots
across her deep wound to heal her with herself.

She doesn't have a word for pain, but waits
for what the roots crave to send that can't find way
to the silvery shake of punk leaves that leave me hurt.

The Sunday August rain paused, the garden beaded
wet, the dirt dark, and the birds of breakfast bugs.
Willow waves in the morning breeze, so proud still.

I hold her. Prayers of no use. I kiss her bark. I sing
songs mothers sing to sick children, never remembered
but sung just like now when that's all to do, when love
cures all or doesn't and we share stories of wonder or ghosts.

Two stray cats the neighbor feeds come quietly,
curl with us and purr and preen, and tomatoes still green
in late August wait and wait for willow to come right.

Where the Wrought Iron Rail Curls

Jack, I met when he said "Good sign there," as I spiked the red
 heart *Love Your Library* placard
shoulder to the shrub rose and behind the creeping thyme. We
 shook autumn hands, and I pet
his basset hound who, I said, looked like she was living a good
 life. I scratched her drape ear then
her chin, and Jack of ball cap, with one of those David Crosby
 brush mustaches, said "Our luck,
she was saved by a second opinion, a CT scan, a delicate scalpel,
 and some more than a few dollars."
That was that of smile and eyes. We waved to the UPS man.
 Grateful. I stepped back in to stir a sauce
simmering from Ed's tomatoes found on the stoop, a gardener's
 gift of September bounty.

I got my second chance for the thousandth time yesterday just
 like today. It was something small.
A stink bug calm on the banister in the sun. Her wings of tapestry
 sewn and of story beyond me.
I was fuming about something somebody said. I was breathing
 like a bull. I was eye-frilled.
I had my hand raised. I had my shoe off. I had death in my
 heart. I was set to clobber and smash.
A crow snapped a shadow and crossed my brow. The wind fell
 into the trees. Grandma's hand
tinted my wrist. The bluegill I had torn the hook from spoke. I
 smelled the campfire song of quiet.
I tasted Ms. Borelli's lemonade. A man helped me when I broke
 my shoulder. I'm still sick.
I was stopped. The sun let me be, and stink bug lounged on the
 flat where the wrought iron rail curls.

To Come Unsatisfy
Because of Marc Harshman

The fire-purple butterfly bush hallelujahs with joy.
In her late July wonder of nectar, she waits
for sun to lift just high enough to warm air,
stir the monarch from their folded limb slumber
and flock to the church of her flaming Sunday bounty.

Our groundhog has become so petulant he refuses
anything but the stickiest of pumpkin or zucchini flowers.
The dog is curled then splayed on the plush blanket bed,
his hips more stiff by the week, and he deep-eyes me,
unsure why the leap into the car is no longer seamless.
I have a scar on my left wrist from a pickle jar that shattered.
On my right, a ghost of sutures and gash from punching a mirror.
One innocent and perchance, the other small and of fear.

Sometimes, I feel as if my heart has had enough and will tear
open my chest and rake in the whole bowl of this valley.
She's had enough of hesitancy and sing-songing her messages.
No more participation trophies. She wants what she wants
and she wants the want that the words I want to come unsatisfy.
How to catch the smell of the broken tomato stem to her without
 a tongue?

A hummingbird sways on the coneflower, beak lost in her crown.
A yellow finch has her way with the seeding grass. I would call
 that delight.
The bumble bee on my forearm offers a powdery gold tattoo of
 her journey.

We Two Prayed

I'm not sure, but I believe
it was the grey, not the tabby
who offered brown mouse, broken.
An oozy gift on the stoop, a neighborly,
feral cat cookie plate—a love-splayed
trophy, different than shiny crow's
I came to alone as the light woke
and door yawned open where the last
potted tomato red waits for a hand.
A quiet moment we two prayed
for mouse and what mouse lost,
and maple sang an autumn leaf dirge.

Small Bites

Just like that, the azaleas are wild yellow, dancing and waving all Spring to come on. I have the mattock. I have my gloves. I'm in the dirt. The hawk there in the sycamore and the rusty cat sneaky under the shed wait for the snap-tailed squirrel to misstep and have his Sunday turn otherwise than sunflower seeds and suet. My leather hand full of some rich weed so obstinate and certain they laugh in my face as I slide the claw under roots and toss all into the galvanized bucket, my offer to become mulch.

Then I fell frantic. I unearthed some sort of plump grub, with white and black ribs twisting and bending in the till, most unhappy for the tactless intrusion. I apologized and knowing no more, opened a hole and begged, yet again, forgiveness, then buried what I didn't know, hoping that was good enough. I don't know what I'm doing. I tend plants that find way to me. I take them in broken.

I touch them as I desire touch. I listen. They whisper sticky songs of pollen and bloom. I hold them when they fear the deer. They kiss me for loam and the luxury of fertilizer. I sit with them. I lie in the sun and root. I make them trinkets. I present them stones. I tell them what I tell no one. I have nothing more to give. I am wholly consumed. These small bites. I disappear. I am of hill. Of buds. Of green. Of hawk. Of squirrel. Of cat. Of tools. Of wet knees. Of bees not yet. Of hummingbirds to come.

Nanc's driving home of horse of hay and her cathedral of field for eggs-over, avocado, and toast. No one told me much about digging. But there they were then, tomatoes and squash and peppers climbing from carved clay-hard small plots behind every rusty house, be damned soot and swing shifts. I'm out here, bald and drenched before death.

"Frankie. Frankie." The moon there, falling behind the far west hill, and the shadows long in 10 a.m. light bend me for thirty feet. Mrs. Ariti, halfway up the twenty-seven steps from the street, elbows bent, extends a gleaming foil-covered plate, her wrists a tender wrinkled tan. She is not much taller than the largest cat. Mrs. Ariti smiles as if she had just emerged from church. I forget the pain in my shoulder. I get off my knees. "Frankie. Frankie. I made loukoumades. Come take."

Some Story

I was chewing on Jesus withering his buddy at the creek on
 Shabbot
when friend crow who leaves bottle tops and painted stones stolen
loft down to the porch rail and nuzzled into the dog's deep fluff
 bed
cawed bright to whomever friend caws between the calling bells
the last steepled church in the neighborhood tolls as I sit here
 Sunday
with coffee and cookie and tear over those hands come up from
 the grave
to tickle me and remember me that perhaps there's a couple-few
 shriveled
things I might want to speak to before out of reach even as the
 crow flies,
who certainly has done all crow can do and would do more if
 she could.

Not Neglecting the Cardinal

The cardinal on the sill, again, waits.

My dear friend knows the seed appears
when light snaps on and the mirror turns clear.

My cardinal trusts me.

I lay my hand to the cold glass,
he tilts his crown. We are in love.

In love, I wait for cardinal to take his seed,
jump to the tree, then wing to his red beyond.

He waits, and I wait. We are reborn, again, today.

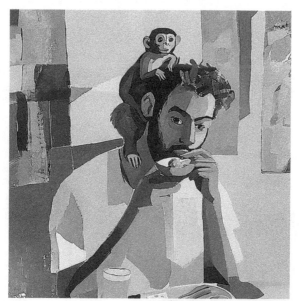

ALL THE WRONG THINGS

All The Wrong Things

The winds must be right. I hear the roar
from the airport ten miles to the west,
people going somewhere to do something
that can't be done here where the dog
rests his head on his stuffed lion in peace.

I am baptized in the holy lick of many leaves.
The newspaper just landed with a smack—
what it wants me to know is too little now.

A school bus stands in wait. Sleepy-headed
kids file in and drop bright backpack burdens
on torn leather seats and push into the half-light,
hopeful not to be taught all the wrong things.

Grave Fingers

At first, I thought it was a slug in my hand. Then I jostled it a bit with my right finger and realized that the tatted kid, immediately annoyed that I tendered for the juice and the energy bar with cash, had, without notice or knowledge or even care, within the sixteen dollars eighty-seven cents change, gifted me a Buffalo nickel which I retrieved, coddled a bit, then scratched the buffalo's butt and said, "Hey, bud." The Indian remained dignified and bold, someone I hadn't held for many, many years and who offered me absolutely no mind.

Did he remember how I had kept him tidy in a blue coin collection binder, only the 1918 and the 1936 entries gapingly empty and without a trophy? If he did, he stayed quiet, and his braids and ornaments kept nickel still. I slid my thumb over his cheek with admiration and pause. There used to be a county park a half-hour south of the city where fathers would take their children. There, following the graveled path, up and through some wide pines, opened a field and fence. And here stood *the buffalos* we had come to see.

This was the time of DDT and the paving of what could be paved. Dad had a '57 blue and white Chevy Bel Air. Me, in Sears Jeepers, hand-to-shoulder urged to stretch between the wire and sink my pink fingers lightly into the tight, curly, forgiving brown fur and touch buffalo's head. My seventy-pound crew-cut, big-eared self, curved and bowed and swirled and tumbled around and over and across, detained and claimed, alive within the near-black buffalo-eye gloss. Buffalo drew and ground sticky hay my brave hand offered. His tongue warmed and wet my wrist. His beard rolled heavy up my thin arm. I slid my plucky palm along his horn. I scratched his tilted cheek without ask. I smiled a smile a father hopes a son will smile.

This errant nickel untangled from a surprise of coins. Finger-jerked from the plastic register drawer and the blind "How you doin'?" to find way to me without giver's practiced hand ever brushing receiver's flesh. Our distances defined and fenced. I keep Nickel on edge, atop the marble mantel, Indian profile facing our living room where the gas fireplace burns a clean campfire. The deer sleep on our hill. I've only eaten rabbit in Italy.

The Native American names given cities and towns in Western Pennsylvania—Aliquippa, Beaver, Blackhawk, Chippewa, Connoquenssing, Monaca, Sewickley, Shenago, Tamaqui—are as invisible and vacant as the coins that travel from one pocket to the next, until grave fingers find way into our startled hands, and we fill the eyes that hold us in love despite tear and taking.

Tomorrow, Sunday, I'll ferry eight-year-old Zuaib in my drab vehicle with zero character through the Liberty Tunnels along the creek meander of Library Road beyond where Schultz Market and the *Coloreds Only* swimming pool used to stand, on a yet-known outing. The buffalo remain, and await his nodded-on tentative eager reach.

Did You Get Healed?

It's the day before Valentine's Day
and she's not here.
Outside the snow is falling lightly
and I'm sitting in front of a Japanese-made kerosene heater.
I'm drifting over Mt. Washington.
It's 1963 and my first days with love.

I'm thinking about shoeboxes wrapped in foil.
I'm thinking about cards and red hearts and be mine.
Love started in the plastic jewelry section of a five & dime.
As the wooden floor ran parallel lines toward the hill's edge,
I asked my mother for a quarter for a stunning ruby ring
for a girl with straight black hair and dark Mediterranean skin.

I can see her, again—proper in the oak chair
with the curved-claw writing arm,
outlined in sun, in front of the square windows,
the string from the pull-down blind swaying in the air the
 radiator's heat moved.

Now the five & dime is gone.
And where the girl is, God knows.
The ring, I'm sure, helps support the ground
beneath a home somewhere near the edge of town.

It's Saturday, and it's cold.
She's in D.C.
It's not hard to see where love has traveled from.
It's not traveled at all:

"Darling. Kiss me. Be mine."
Love wrapped and coated and printed and signed.
It's a candy-apple-red world where the arrow pierces the heart.
The only place I know where you get healed with pain.

Thin Silence

Jimmy Sange came home from the war with half a heroin
 addiction and a Vietnamese wife.
Father Pat understood the urgency of Jimmy's situation. Pat
 returned in like shape after
ministering to boys who found the moment too far from Iowa
 fields or the Pittsburgh mills.
There, God was of no use, but the deep sweet dream of opium
 opened him to lay his hands
in good faith on the heads and shoulders of stone-face kids no
 excuse of flag can excuse.

Pat took Jimmy to the park, and they tossed balls and let the
 dirt, breeze, throw and catch
unfurl the tangled knots of rifles and sin, and between these two
 men almost without word
Jimmy's eyes came clear and Pat ever certain that Host and wine
 were best for the less guiltless.

Father Pat passed when he was seventy-seven. Jimmy Sange
 made way to college and work
that ministered and cured animals of ails and served the deep-eye
 love nubs of man to beast.
Jimmy's wife, Thi, brought to the pot-lucks of the times her
 noodles and mixed meat bowls
carrying names no one could pronounce or remember but
 remembered her deep long smile—
poetry in the days when the neighborhood held hands. We sang
 songs tiny with words.

Come to Pittsburgh, I'll take you to Skookum field. We'll stand
 between the lime lines.
I'll show you the bent foul pole. I'll show you how close we are
 here to the clouds beyond.
There's too much this to leave. Jimmy Sange was a lucky one.
 Henry Johns not so much so.
I'll show you our rivers. I'll teach you our verses. We'll warble,
 and you'll know the thin silence
between not and now. I'll fill your sacks with our coal stones.
 I'll gift you a monkey ball.

If it's Saturday, a little league game starts at 1 p.m. We'll have a coupl'a dogs and a Pepsi Cola.
There's a bronze of Father Pat in the dugout. Let's touch his cheek and sit on the oak bench.

Cave Tease

It was the day that Walter Wenders crawled into the cave tease
 on the tree and rock hill
between the VFW and Skookum Field—some ripe-open remnant
 of what men did here
before the streets were paved good and the houses sent their
 kids clean to the two schools—
when I gleaned some things are best left undone or done better
 somehow at a better time
not including perturbed firemen and the flock of dads with
 ropes and pickaxes cussing
to wrench Walter by lassoed feet into the fresh light and torn
 chin mercurochrome stain
of an open ass-beating laid by Otto Wenders on Walter's arse
 and two months grounding.

And Walter's folly had me in Dutch 'cause I was with him when
 he set head into the dark.
That was enough for Dad to give a loud earful, a good thwack
 or two, and then a head rub
for the good sense of having some sense to not crawl into the
 earth. It'd call when ready.

It was half a block from here, where the firemen and dads
 breathed beers and smokes,
I sat at the kitchen table wedged into the deep cave of teenage
 chatter with Helen Metzler.
There we talked of half dreams and dare wonder what happened
 beyond this hill and rivers
that we teeter toward and bid us like the split-lip lure that slither
 in our retrieved Walter.

The 40 Mt. Washington, on layover, idled there just outside her
 house, the conductor waiting,
the trolly wheel snug to the line, his schedule pulls neighbors to
 the corners and car stops
where two doors part and three rubber steps receive, and the
 fare box that knows our dimes.
The lift-up windows, the silver poles, the leather benches, and
 the rock and clatter in time

that Helen of flowered tops and hazel eyes and of mom's strudel
 and John F. Kennedy photo
and me of bangs and letter jacket and public school and of no
 nun United Church of Christ
found what was before the love lust of body and sweat, of aisle
 walk and vows and mortgages.
Maybe a slow dance, maybe a handhold, maybe a kiss, never
 fathoming the Motown FM
we sat in and swayed, plays, if we do dare, for us in our atticed
 boxes, our time of pen and stamps,
our time when the rivers would wait, and we love there something
 the tempers of fate may not bury.
Our caves come for us. Our caves open and swallow. Caves lit
 warm with what's remembered.

THERE GROWS THE SAVING

The power went out last night right when the movie was about to offer its reveal, and after a grumble and some chuckle, a pleasant guard ushered us with regrets from the theater carrying a torch he claimed could reach the moon.

Outside, the streets were city dark, the buildings flat. We were relieved of knowing the end. We were set out into the night. We bumped shoulders. We said, "Well, what d'ya know?" We were light.

The *My Eyes Were Shot Out In The Mine* man sells yellow pencils. He notices our shuffle, his dinged tin rattles the music of quarters and dimes, and offers a thought to the mingle, "Lovely night, you see." Nanc gave me the soft elbow and the head nod. I tucked a bill into his cup, he dipped his capped head. The pencil taken turned in my hand.

The river sang her hymn, released from the burden of reflection and post-card beautiful. Still, she accepted the coins we tossed from the bridge. Each plinked then zagged through her thick, bouncy March current.

She may have read our fingerprint wishes if she were in the mood. Biddings, perhaps, to appear from the dark of a tomorrow not yet here. But we held hands, let the river be, and made way to the car.

The pencil remains unsharpened. The movie ending never seen. The dark offers light that no one yet wholly catches. In my cup, my sins and blessings clatter. It's my hand in the night that clutches after what I know lies behind the heart. There grows the saving.

As God as Anything

Johnny Johnson just paused to wave ahoy
up the hill to me beyond the butterfly bush.
This, before most doors crack and the pull
of Sunday's routine gets into swing and song.

Johnny's dog has no left eye and a scar across
his shoulder, a story, I guess, he'd tell if he could.

It's August 25th, the maple now ready for winter,
her leaves yawn sleepy brilliant joy before sap sleep.
The small bees continue to swim in the thyme
and the burly bees sip on purple ice cream cone
blooms with a name that I do not know.

My inherited ghosts sit in the dirt and on the porch.
Yesterday, Tom Wilson's wife was taken quick
into silence where her voice and smile live in dream.
Later today my flag will argue with Larry's,
but now they're twisted about their white poles,
snarled and stuck by the rip and snap of a storm
that ended the ball game and pulled windows closed.

I am paralyzed by what's too much to say.
The rosemary, as God as anything, offers herself
for the sauce and stir and the dish to come
when yeast has given and the bread has burst to table.

Saved again and again before the bells ring.
Heart waits but the dummy can't go it alone.
Johnny's dog, Jasper, tilt-heads me for a treat.
Hold me. I'll give all the paint the canvas will take.

It Slid Slowly By

Krinky Wilson's eye came out of his head the day following the Fourth of July when he split the telly pole at the corner of Sweetbriar and Wells with his '71 speckled blue and white Charger. Krinky went face into and part through the windshield, and Krinky's left eye kept going. When Jeff Kroenson's dad got there, Krinky's eye hung from Krinky's bowed chin, a still pendulum of the day's adventure.

And if it wasn't for Mr. Murphy, Mrs. Benjamin's garage would have fully burned. The powerline and transformer plotzed across the roof, turned shingle to blaze. A black signal rose, pulling doors open blocks away and the people to porches and sideways into discussion of "what happened?" Mr. Murphy, then Mr. Vertullo, pulled open the two hinged wooden doors of the Benjamin garage and pushed Mr. Benjamin's 1943 Mercedes safely into the street where a handful of kids out with the spectacle sat in thrill along the wide running board. The car hadn't been driven since Mr. Benjamin died but was kept up by Mr. Freddy, whose garage and flame-yellow tow truck had come to the rescue and relief of everyone in the neighborhoods on our hill.

For years, the Benjamin Mercedes was the centerpiece of the three parades across Duquesne Heights when men and boys and girls wore uniforms of some sort. Those times of flags and bands and salutes. Mr. Benjamin somehow had the Mercedes crated and stowed on the freighter that brought him and six hundred and thirty-seven other men back from the front after the war. He was proud. His booty of exultation. His seventy-four hundred pounds of German comeuppance that was his and that he shared, surrounded by tubas and drums and flutes and clarinets when everyone leaned a bit forward fascinated into the light and touch of victory and future the Mercedes offered as it slid slowly by.

Closer to the mist and clouds than most, my hands drip with the honey of our hill. This Pittsburgh, where gathered and found, sitting on coal dirt, we remain people still of screen doors and cramped kitchens, forever crossing a bridge or exiting or entering a tunnel. There were seventeen churches alone in our neighborhood. Our breath and soil sweep down the Ohio, gone. And even when we don't, we care and clasp what is unasked and given. I keep a

rosary in my left front pocket, which does me, God knows, any good. I dress in this sacred garment of streets. I ring the bell of the 40 Mt. Washington I stole from the scrapyard. We know her clangor song. Krinky's eye but one moment to our hollow hearts. The quiet between the knells is all we can take. Then, there are tomatoes and squash, seeds through which we carry on still.

Labor Day 2024

In the park for one day
Hunkies and Italians
held hands.

The cheer of tool and beer
and the grilled meats wave flags
of men gathered with wife and child
to park and games and songs free of sweat
and broke back and dirt so heavy
to refused bath and soap.

The quiet of bands and parade sound.
Tables filled with elbows and plates
and tongue-twisted English laughs
everyone understood.

In the run about of three-legged races,
egg-toss, hurrahs and victory claps
Mr. Glogowski snatched me atop his shoulder
to a heaven. "My Matka under pear'eh tree
near stone wall Papa build on hill by river my home."
Mr. Pescatore pinched a deep heart cheek pat,
"Your daddy, good good man."

Yesterday, I fixed a switch
with an orange-handled screwdriver
I found back then that maybe a guy
missed and mourned when he reached
to remove a plate or hinge.

It speaks of pierogi,
of mortadella,
of cabbage,
of grape,
of cross and candle prayer.

I have a stone in this knee. The dry ice
still bubbles in the creek no rock can reach.
Moms dressed us in bright outfits.
We their show and shine that refuses defeat.

This, how we were before, I guess,
the new war showed us for what we were.

What these men knew
but had no time to figure out
more than they knew claw and scratch
got them a little but never enough
but enough to not stop to dance.

As Though It Were Not Yet

When I picked up the stick and whacked the Shechkins' dog, I knew then I was doomed to my desert of failed expectations and never enough. The Shechkins' dog and I became fast friends. We went to the river and swam. We took to the field and chased balls. Either he forgot my ugliness or forgave me of dog heart and deep eyes. His tongue found my cheek. I held his big head, and we both drank from the hose and laughed.

Burnt across my right palm, the scar of that wielding mangled the drawing God had etched. My task of tabernacle and menorah haunted and sputtering. The cloth never strained properly. The fires misplaced. The candle teeters and tumbles from the cup. The people impatient for an answer I can't quite make. Try as I might.

Maybe, like the Shechkins' dog, God, I can't remember if it was the fortieth or fiftieth year or today, had had enough of me or took pity on me, or perhaps simply given a stroke of luck, I found the squirrel on my sill, waiting for me to extend my soiled hand to offer a nut and to let him climb on my arm and up my shoulder to talk clicks and grind our teeth together on the fear of snapping tales and hawks.

I've opened all the windows. The doors are gone from the hinges. And my animals crowd me of feather and fur and sing and gnaw. The chipmunk lies in my palm. She rolls and curls and makes her nest of my sin. Her caress teases of love as though it were not yet. Maybe this is a start? Maybe.

SMALL PICNIC
To Tim Russell

You may have seen the cook dancing in front of his silver pots
as the tug churned its way up the dark Ohio.
You may have been face to face with the small brown bird
graced with grey speckles as sweet Violet mounted her tin-can
 stilts.
You may have had mixed feelings as the Memorial Day singers
coveted yellow ribbons and sang "America the Beautiful."
Then again, you may never have been to Toronto, Ohio.
Never have witnessed the watery spine of four-hundred
 communities
lap light from the humped moon on its rock banks.
You may never see the unloved white dog, condemned to his
 short leash.
You may never touch the painted war memorial
or walk to Yummy's for a double-chocolate cone.
But certainly, you can understand
how a man can sit in shadow on his cool porch, content.
How a trailer court can erupt in the heart of a small city.
How the Black state high-jump champion can go unrecognized.
America is so full of beauty and indignity.
I'm full of hamburgers and beer.
The health care and greed issues remain unresolved.
And after the candles are extinguished,
the cans rinsed for recycling,
the hand shaken,
can you appreciate the fifty-mile drive back to Pittsburgh—
where you too may never have been—
drifts by as effortlessly as eyes rolling into sleep?

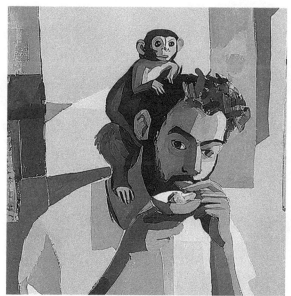

OUR PROPHESIES

Miss Addy

Everyone knew that Miss Addy was no one to be pulling any foolishness with. No. Miss Addy lived through or drove off more men than anyone could remember. Though everyone remembers Mr. Ezekiel because Miss Addy was cheery in those days. And Mr. Ezekiel made them a home and he, almost all by himself and his thick arms, built the church Miss Addy still goes to.

After Mr. Ezekiel didn't come back from the war, Miss Addy was never the same. She did all the things she did, but it seemed like she always did them dark, and she had a bite and a fallen smile. Them men, sorry and not, could never live up to Mr. Ezekiel, and the torn heart of Miss Addy never did find a balm or a kiss to stitch it back the way it was when Ezekiel tended her light. It wasn't as if Miss Addy wasn't still living and keeping herself up. No. She made sweet-potato pies and her meat-vegetable stew that no one could ever match, and there was never a lick left at the potlucks she graced. But sometimes, and you knew when, Miss Addy would get to a place where she was having nothing of nobody.

Sometimes it was around the date she received that letter telling about Mr. Ezekiel dying trying to save someone who maybe he didn't need to be saving. Or sometimes it was after she watched the TV news, or she come home from town. Or sometimes, no one knew what it was, but you could tell. Miss Addy would go quiet, and her face stiff. If you tried to cheer her up, you got snipped and sniped, and it hurt, but she was protecting something that needed protected bad.

When Miss Addy went quiet, you best just let her be and tell anyone who didn't know to let her be until she was ready to come off her porch or call you to come near. When Miss Addy was in that way, at night, the crickets were smart enough not to cricket. Those nights I prayed for Miss Addy to come right, cause the quiet was too deep to bear.

Our Prophesies

Paul DiFiore lived in a last house on Hallock Street, a 1950s squeezed two-story red and yellow brick across from the right field foul pole of Olympia Park. Beyond the park, a ravine of rock and ledge and dumped stone and dead appliances that shear and fell off the edge of Duquesne Heights onto the opening of the Fort Pitt Tunnels. Balls that found their way there were gifts to a god best left quiet in the sycamores and ailanthus. Mr. Cappelletti had a slinky black and white up-eared dog who ventured past the fence and returned with balls, waterlogged or not. He had a job and did it without complaint, and Mortar, that was his name, never chased balls in play or waiting in the tight grass until we collected them after practice.

Paul didn't play any baseball. He wasn't built for that. He was more for books and thinking in a good way. He had a voice and eye that took him to KDKA, where he did things to make the radios stay on schedule, then found way for his fifty-thousand-watt accent to carry far, to Chicago or Boston on a clear night or to some Pirates fan tweaking the dial to 1020 AM to fill the car or porch and the kiss of a pilsner. Most everyone here just kept the radio frozen there.

Paul never made it past the 40s. Something crept or flew or slunk from a dark wood and filled his body with something his smile and heart could not kill. Mortar and Mr. Cappelletti and Paul are all gone. Mr. Bernie is gone. Mr. Miller is gone. Coach Marino is gone. Coach Schmidt is gone. Coach Riely is gone. Coach Stepula is gone. Miss King is gone. Mr. Hamel is gone. Jiggers is gone. Flash is gone. Nubs is gone. Pulled and taken into the woods and abyss that surround our hill that no dog can bring home.

We didn't know what we were doing, after practice, backs pressing that fence, gnawing Freeze Pops or ginger ales and chips. The branches in motion. The stones biding time. The appliances rusting in loneliness. We sat there. We rose. This is as close as we came. What we took on our ways, the prophesies of the life we were only yet to speak.

Most of us still here. Touch a tree. Throw a rock over the edge. And on occasion, defiantly toss a bottle to hear it shatter and

clatter and howl wonderfully through the steel girder back and shoulders of the colossus neon Iron City Beer sign pile driven into our hill. It flashes and flashes down to the city there. It's as far as anyone has made it and returned. We dare and do. And we have then voice to speak of love. Until we don't.

Seven Years Ago Yesterday

I was buying cheese and olive oil and pizza flour and some Italian
 cookies.
You know, lost in the market of worn wooden floors and tin
 ceilings and aged
photos of pushcarts and knickers and dogs that follow those
 boys in heaven.

It was warm for late November. The sun pours straight down
 Penn Avenue.
I held the door for a couple. I fetched a monkey a giggling
 toddler tossed.
A tall guy played "Ave Maria" on the accordion. The quiet noise
 handholding
steamed in the eyes of a fellow who kissed his girl on temple
 and saw me smile.

I was thinking of Tony Buba coaxing yeast and flour for a week
 to make Pandoro.
A woman in a Christmas vest, a red flame tattoo on her left
 forefinger knuckle
grabbed my right wrist lightly, turned me and said, "Here,
 mister, please take this.
It's an ankle bracelet of Christ. Can I put it on you?" My shadow
 stuck under her feet.

I slipped up my left pant and slid down my long sock and her
 cool hands wrapped
a chintzy silver chain with dangling golden Jesus heads that
 bounce on the bone.
You're the first person I've told this to. This happened seven
 years ago yesterday.

We Are Separated by the Thinnest Filament

These two things happened on the same day. First, a green flame-tailed fireball halted our baseball game. We all pointed and watched it disappear behind the trees into the city, convinced it was a flying saucer for sure.

Second, before we could run home to tell somebody what we saw was a bird shat right between Bobby Luno's round glasses and his left eye, and we laughed hard like kids.

"Do you love me?" was the last question my mother asked me before the nurse sent me home; "She won't go if you're here."

And here's more of that fall-down kind of cruel black humor laugh. Walking to school on Virginia Avenue just by Slater's Funeral Home, a starling whizzed right by our faces and flew squarely under the front tire of a blue Buick. The feathers kick-up *poof* like a cartoon. How could that perfect, bad-luck timing happen? I still hear it—the crunch, the screech, our hooting and pointing.

A ghost wind came as we buried my grandmother, Immaculate Nickels, on a wet, cold November morning when I was a high school jock and had no idea of pain, dark and cut as the hole the casket fit. An ice-scythe swirl slid through us all and quieted the minister. I knew that grandma was taken, and the way she read cards as real as the night Bell Ahern, whose house we bought, came to me in dream, shepherding an underground water journey, lifting me from a gondola onto a wet stone platform to peer through one door then another to see her story before sending me back to sleep and the morning call telling me she was gone.

I remember learning to use chopsticks in a Cantonese restaurant in Canton, Ohio. Driving wildly with Patrick to Cleveland on the wrong night to see a concert. Dancing nude and hooting from the roof of the 4th Street parking garage. Tramping across Mt. Washington with our Boddhisatva dog, Bupp, through three-foot-deep heavy wondrous snow, past St. Mary's before cell phones to surprise Nanc at the Monongahela Incline finding some way home from work.

A night when the world was silent and covered and wide and white and alive.

And who doesn't love their mother? No matter the excess rope by which she knotted you and pulled you and kept you near. A token. A totem. A hope. A fill-in. A balm for what she was not or did not or could not be. Learning to breathe without being caught breathing air you claimed as yours. And that's the way it is, these weights, that God knows why, we just bear this day and that day and the days we forget the bearing and kiss living.

"Yes, I love you." How could you not know? But no one ever said such, so fair enough. I brought in the rosemary. It's not right not to keep her near.

Shit Prayers

It's so cold this morning
the titmouse and the cardinal ignore the cat
to dare feast on the feeders
rocking in the wind, church bells calling
the neighborhood yard flock
to calm their jumpy bellies on spicy fat.

Three bare sycamores outside the window
in a claw-and-grab gust dance,
stop quick to tender touch branch fingers
in this joy whip of January squall.

I maybe noticed this because of Father Pat,
who'd come visit his brother Paul
who lived in the basement
of my friend Johnny's house on Augusta Street.
Father Pat grabbed us by the ears
and smacked us on the heads, lovingly
smoked Lucky Strikes, and poured his Duquesne
beers into a pilsner glass,
never failing to ask us if we were doing right,
not in the church way but
right in the way you know you're supposed to do right
that no lie could hide.
That was all the church I needed for a long time,

and the dollars he gave us
to go to Helen's to buy pizza and Royal Crown cola
to talk stupid boy talk
in the two-tone booths in the back room
with a jukebox that needed no coins
I still spend without end.

The novena, not nine days
but maybe nine decades.

"No more shit prayers, boys."

I'll shovel Larry's walk
before he returns from mass.

Dick Teddy

Small Dick Teddy we could count on. He had the knack to go with the pitch, get bat on ball and move the runners up. He was clutch and, in short order, made his way to Triple-A in Altoona before catching his breath and pitching his future to engineering, twenty-six years at Bayer, and the kids he'd teach the art of clutch.

But for all that, Small Dick Teddy was remembered as the son of Big Dick Teddy, a long-haul driver who laughed so brightly the neighborhood came to their stoops to wave to him when he parked the red and blue cab in the nook he carved between the Teddy and the Hoffman houses.

But the tie and curse Small Dick Teddy carried was the lore of Big Dick Teddy's rampage of sorts. Big Dick had returned from a September fortnight that had taken him east to west, then south to return north and home. Big Dick was back but an hour and hadn't had the chance to dispense his roadside gifts before he pushed overheated through the gloss Kelly-green front door, fired up the cab, and drove three blocks to Amabelle Street and directly into the front door of the Mancelli house, crushing the porch and banisters and having the grille's angry clenched jaw rest against the upright oak Kimball.

Big Dick Teddy sprung down and beelined into the dining room and left-hand snatched Michael Mancelli from the chair, the lamb shank Mrs. Mancelli had tended most of the afternoon naked and full on a hand-painted platter from hill town near Sienna. Big Dick Teddy then slapped and slapped Michael Mancelli until his nose went a bit crooked, and blood rolled down over his lip and across his chin and onto the chair's white cushion that would now need to be reupholstered.

Though no one knows for sure, Small Dick Teddy carrying this load kept whatever he knew locked in the trailer of his tongue. But the tale goes that Michael Mancelli, the pharmacist at Thomas's Drugstore, had slighted Mrs. Teddy over sleeping medicine and some smug inference that loving men didn't leave beds cold and half empty. Whatever the full truth, it was enough for Michael Mancelli to come before Mrs. Teddy broke shirted and lowered eyes; his act of contrition that Mrs. Teddy accepted with her left

hand falling on his mortified shoulder, her diamond catching the blueish streetlight. For a second, she pondered if Michael Mancelli hadn't been on to something. Mrs. Teddy continued to frequent Thomas's, and Micheal Mancelli served her until the store was closed some ten years later. From that day forward, Mrs. Teddy shunned the sleeping medicine. Big Dick Teddy sent a couple of guys over to help with the repairs to the Mancelli entrance. Big Dick's wheels rarely left the tri-state. His grille just off-kilter and worn.

Small Dick Teddy never raised his voice on the diamond, or to anyone really. Small Dick Teddy was clutch. He understood the game. He hugged the plate, choked up, and answered the pitch's demand to go where it wanted to be taken.

I played one year of college ball. Maybe I should have stayed behind the plate, calling the right pitch? I knew better. Then there was the time I stormed across the street and through the Pajewski's side door to snatch up Paul Pajewski by the belt trying to bolt upstairs and away from the three or four right hands I laid square on his face, before heading proud back home, his broken belt, now, all mine. He shouldn't have spoken back to my father. My father taught me right. But he taught me better. He appreciated the effort but sat me. That ball should have been taken to right field for a double.

"You hit a loud, long fly that left the runner on first. Now, where are we? Hoping the next guy bails us out."

SWALLOWING DEATH

Pardon, please, the name-dropping. P. T. Raju, it turned out,
 was a big-deal Indian Philosopher.
I found myself in his class. It was finally Spring. The tall, long,
 thick-paned windows lifted high.
God, I was wonderfully lost in Ohio, knowing so little I carried
 a pocket full of rocks for luck.
I remember two things. The Cārvāka pooh-poohed causality,
 and Dr. Raju's mother made curd,
tipping fresh milk into a tin and setting it atop the radiator. She
 dished it over oats, shooing him
to school. I was sent along after powdered juice and cinna-
 mon-margarine Wonder Bread toast.

Was it then that I first swallowed Death? The oaks outside the
 window and bagpipes wheezing.
The warm breeze laden with pollen covers our sills golden in
 which we carve our finger art.
Whether that was the first time, or had it been learning to hit a
 curve ball without thinking,
or was it the thrift of sitting early and alone on a dock, watching
 a bobber wave in the cove?
For these years, I have been looking under rocks and interpreting
 the sound of shadows.
I've painted my hands and pressed my mark hoping someone
 sometime will understand the signs.
But that's not what I've been doing. I swallow Death. A wedding
 table of cookies is Death.
The more it turns up, I claw that stench into my big mouth and
 chew chew chew Death—
you bastard that cheers us to tremble from our stomachs and
 hide in closets and hold broken dolls.

Who am I to turn the deer away from my shrubs? I swallow
 them hoofs, horns and all.
Symmer and I shot Super-8 film in the Bowery, swallowing it
 clickety at 16 frames per second.
In a Fall night rain mist, Walt and I set a bowling ball alight and
 pitched it from the 9th Street bridge.

It splashed flame from the Allegheny and, bent over the railing,
 drenched in laughs, I licked
and drank and spit and rubbed it wildly over hair and face and
 hugged and danced drunk now—
all this Death I take. Even Jeff Oaks absconded yesterday, ahh, I
 shovel his poems and paintings
down my gullet and heave and delight, life sick. His smile pours
 down my chin to tear my chest.
I am lashed with Death. Scarred and marred. Belly full. I take to
 any ring. All comers welcomed.

Mrs. Raju's name is Bhoomi, the steam from her radiator whistles.
 I am curd to swallow Death.

To the Shape of Desire

All the chard, forsaken and limp, desired or required was a deep bowl and some cool water. She undid her rainbow leaves. Sunday peeked between the two tilted pines to lay eyes on her and felt shy before the luscious, ribbed bosom of chard's welcome tease. My heart let the coffee go cold.

• • •

Last night, Patricia asked me to kiss old Abe in case he was gone the next time we visit. This good brindle boy of limp and lump and of bright eye and treat who asks not much more than a scratch and a big head on your soft hip. I didn't sleep well. The *other* night too, too much for lips and flesh. How about a couple of brekkie eggs?! The petunias wide open. The jay unlikely to worry.

• • •

There's some submarine movie I've never been able to shake. I was a kid. WWII. Skinny guys, T-shirts rolled up at the bicep, sweating and smoking. Breathing one another. There's a cat, and the swabbie who loves her. Swabbie goes to storage to get Tabby a tin of tuna. A depth charge. The waters breach the hull. The compartment door swung shut and wheel-spun sealed. His buddy, not knowing in there was Swabbie. All they can do, Swabbie holds Tabby, is place palm to palm against the portal glass. Swabbie mouths to his mate, "It's okay." Tabby looking at Swabbie. The sea fills the window. Then nothing. The friend screams, his battle station calls. This last graze of hands will have to do.

• • •

Skip with me, will you? Beloved. There's too much future otherwise.

Not Giving Up

Chelly McCoy got it bad the summer of the riots, and if we wanted to find him, we had to drive over to Beechview to *The Wall* at Moore Park. Chelly would be there with Cheryl Koedel, who had brown bangs, green eyes, and toned arms she would rest against Chelly's, holding hands and kissing some until Cheryl had to be walked home, then Chelly'd catch the streetcar to The Junction, then the 40 Mt. Washington back to the where he belonged; but we all want to leave for the giddy lost arms of what not yet known.

None of us knew anything about anything Greek other than the Spiros sister, whose olive skin made me sweat. In a short order, most of us gave over to Aphrodite's whoosh. Harry Ferrie to Sandy Higgs. Johnny Anster to Barbara Bocks. Flames snapping from the mill stacks of our hearts, pouring something steel and permanent, even if only doomed to rust. These were the end of the days of slow dances and spin-the-bottle in the low-ceiling basements. We lost our senses. These girls twistered time, and it was hard to breathe, a frothy throbbing mad panic of nothing but her.

We learned to forgive one another for these first addictions. To be wanted and held, no matter if only for a month or two.

And it's still hard to breathe. We're perched and leashed to a tired hill that gapes down on this city and our three rivers. One muddy. One clean. One empties prayer into a sea I've not seen. She opens herself. She sends clouds and mist and whispers you may have never known. We own this place and speak a dialect knucklehead hard and blood warm. We can't quit her. I feel silly loving in words that can't find themselves.

I slather. I slaver. The shit Socrates hated—the tease of Janet Broccolo's chocolate eyes and curly Italian hair. We get kidnapped unbeknownst willingly by love's hot tongue. We return. We come back. No heartbreak too much. We're not packing it in. Not giving up no matter how she may flee or tease. It took Danny Hudson twenty-five years, but he found her, and we rejoice. He's never left us, and we love him because he is ours.

My hands callused. My knees scarred. My joys a halo. I smile a fool. A fool for you I love. We are lucky, we are. Someone waves a beacon from the mount yonder and we wave back. What else are we supposed to do? It's all there is to do. Love is the laugh that I'm still here alone or otherwise. Come to my garden, I show you my trinkets and stones. We'll catch our breaths. The figs are near ready. Sit with our ghosts, they can't leave either.

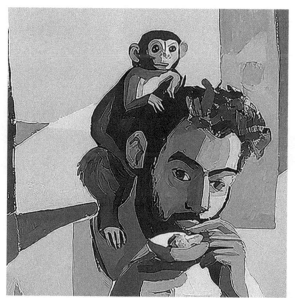

JOYOUS PAIN

Venus

Even city light can't drown beauty.
She has me bad.
And I find her
staring at me just there,
four-o'clock high,
and I stop.

She pulls me hard,
grabs my neck
and two times
bites my lip.

Horns blow.
The cop whistles.
Some kids giggle.
A tiny dog chases tail.

Nothing I hear.
I've gone all woozy.
I am hers.

I remove my seatbelt.
I step through here to her
where I learn her hot tongue language
until she slips out of reach and leaves
me silly for twilight tomorrow.

Too Much

Already this morning I've broken
Holy Commandment number six.

I am as confused as the dutiful ants
who found the blessing of manna
and gathered what they needed
before I laid spray and paper towel
and swept and washed and disposed
of their wee bodies not to return home
where they find their kind of ant love
of touch and work and sleep like us.

I sit faint and watch the light come.

My coffee's gone cold and meal unfinished.
All this too much. What fast can save me?

Joyous Pain

Linda Polito clawed the right cheek of Bill Stanford for good
 cause.
Bill had lain his left hand on fair Ms. Polito's fine right breast.
We all heard her grey cashmere pullover spark and crack at the
 touch.
And it wasn't that blood rolled down his cheek, the channels
 filled like tears.
That was really the end of it. Like that, Linda became legend,
 and I imagine
exposed a life of much more wonder and interest than knuckle-
 head Stanford.

I remembered this ancient moment this morning outside St.
 Paul's Cathedral.
It's three steeple glorious. A woman sat on the stone steps and
 waved me over.
"Would you like to speak to God before you head in?" extending
 a stone ear
ringed to a thick, braided silver chain she wears around her
 neck, bosom close.
For the last day of December, it was sweater-warm. The sun
 yanked me down
next to her of pillbox hat and two corduroy jackets with crescent
 moon buttons.

"Go ahead. Tell God what you desire." Naked, on the spot here
 with her.
I paused. I reached. I bent to her. I took the ear in my palm
 walkie-talkie style.
We tangled quiet eyes and crooked smiles. She held my hand.
 Did you kiss God slow
dancing close with Marianne Pysola to the Delphonics's "La La
 Means I Love You"?
The bluegill? The giant spider? The black snake? The torn
 thumb? The home run?
Tell God, Frank, what you desire! You moon. Hollow and half
 full! You cheer.
You shiver. You paint stones. You speak to the dead. You know
 bread and books.

You tend your dinner. You set the table. You shop. The butcher
 knows your order.
Your knee hurts. The calendar is almost out of years. God is
 listening listening
The stone ear is in your hand. God is in a gray cashmere pullover,
 soft and regal.
Put your lips to his ear. God's breasts are teasing and firm. God
 wants your desire.
This silence. The steps. The doors have swung shut. You've
 missed the service.
Tell God you desire Linda Polito's outline, that totem, the bounty,
 our joyous pain.

What He Gave Me

Dad has been coming to visit again.
He was on the porch last night, quiet
outlined in sunset as the garden went dark
and then, this morning, when I went
to water the rosemary and the fig.

He was standing on the first step
looking in through the screen door.
I touched his short-sleeved shoulder.

Maybe it's summer? Maybe he knows
I'll need someone to hold the light still
when I replace the oven igniter later?
Maybe he's been there all along; maybe?
But usually, when he visits, the squirrels
sing, and the blue jays leave nuts on the sill.

When I returned from the market with herring,
he'd clearly been to the basement and back.
His red-handle pipe wrench on his thigh,
turning the radio dial, looking for the ball game,
Bârü settled across his feet like it's nothing.

What does it take to break a man's faith?
Clearly, the War didn't help. Yet it was more.

I keep this posed photo of him in the later '40s
at St. George's Lyceum on Arlington Avenue,
mustached, open-shirted, young, cocky, and full—
there he sat with beer buddies much before Mom.

All I know, Dad in those days would retreat from the noise
to the silence of the monastery and hole up, looking for
or sharing whatever one gets among the candles and whispers.
Then that God went dark. Christ and the whole caboodle shucked.

What he taught of the church was through the oiled glove, the
 small garden,
the clean tool, and sitting on a dock without a sound, watching
 a bobber.

I guess I have that gene, too. My candles and vespers
of painted bricks, words, bread, canned tomatoes.

And I guess we all lose something that made us:
the streetcar, the corner store, the little league uniform,
playing in the street, home when the streetlights come on,
love. This is why I go to St. Paul's to light candles.
Dad's faith has me not give up what he gave me.

It's lunchtime. I'm going to take him a sandwich and a pilsner.

Between Language and Jouissance

I've never had a rhododendron for a friend before.
We became acquainted after I put on my boots
to negotiate peace between my other two friends,
the cardinal and the blue jay.
 They saw me coming
and abandoned the peanuts and zipped into our rhododendron
 to hide.
I noticed her leaves folded down and her buds waiting,
mocking winter, using snow for fashion.
She's wearing a hundred white Russian-hat flowers!

Before I began my discussion with the cardinal and jay
I noticed the dog—rolling over something under the snow
in the path left when the streetcar disappeared—
had absolutely no interest in the grand détente about to commence.

Cardinal curled in on herself near a Y in the trunk.
Jay limb-hopped and screamed that every peanut is his.
It's taken him a million years to work out the circling raid patterns.
I wondered, again, why I take on this job.
The last negotiations were just signed:
Cardinal would get peanuts shelled and on the sill.
Jay would get hers whole on the banister.
Now, with the snow, things have changed.
The contract held no snow provision.
 So, here I am,
without a coat, bald head melting-flake wet,
pleading with my representative friends,
"Can't we just discuss this?"
The jay won't shut up. The cardinal won't speak.
"There are enough peanuts for everyone!"
I try to keep them occupied.
I don't want the squirrel entering the talks; I'll never get this settled.
I don't want to threaten them with the crow, either.
They'll both pout till spring.
I know what it's going to take to restore peace.
Jays like numbers, so I jabber percentages and volumes.

Cardinals want exclusivity, so I speak sill width and sight
 protection.
 Finally,
both relax and there is a pause calm.
As they look each other in their dark eyes, I breathe,
touch fondly the leather leaves of my patient new friend.
We all know something else will arise tomorrow.
Right now, all I can see is the bare skin above their feet
neither red nor blue, more pink like the dog's belly.

ALL THAT FORWARD
Because of John Repp

It's the looking back that drove Rose Winter crazy.
Some snare of claws and brambles and wind whistles.

She could not find release here and craned, always, her
neck there until she disappeared into a rearview world

nobody saw but knew was mad real in what remained
of her sweet smile and the soul songs she sang when I

brought her madeleines and had tea on the window seat.
Then I had hair, and a book and a pen in my coat pocket.

And when I left, I kissed her eyes and pin a poem
next to the others above her desk and walk the three

floors down from her flat with clear view of The Cathedral
through the grab of old rug, loose steps, and dirty paint

that unsealed onto the fresh bright blind of a brick alley
behind Polansky's delicatessen and the noisy headshop.

I stand for a few deaf moments with a black-eye blue jay
who never second guesses or regrets the seed she takes.

Tulip Continued to Blush

This snow has not deterred
the red tulip from standing
her ground. Neither the cat
nor the blue jay paid heed,
yet the squirrel found joy
and ran about and sprang
over her and cozied her a nut
pinched from the clacking jays.

Squirrel clicked. He barked. He spun.
Squirrel danced proud for her smile.
Squirrel snapped snapped his tail.
Squirrel opened her nut for her.
Squirrel took to the elm and shook.

A leaf fell. Squirrel leapt to the rail,
skipped twice to chirp and pose
legs and belly atop the stone angel's halo.

Squirrel dove and slid and kicked snow,
moseyed up to her slow in his grey suit
and stood tall on tail and sang and waved.
His leather paws filled his cheeks with her light.

Squirrel bowed and dared let his whiskers touch
the slick damp curve tongue of her shy petals.

Squirrel clacked clacked his teeth and silly boy
flashed off in delight beneath the yellow fence.
Amazed at his daring, so laddie smitten was he.

The generous young hawk simply let squirrel be.
And tulip continued to blush.

She My Eye Blue

Tucked in the morning's wet snow blanket
a lone tulip pushed her red face to the sun.
She wore the white shimmer as a crown
and winked when she saw me smile at her.
Soft green dress hug sleek along her curve.
So, I stopped and stooped and lay my fingers
lightly to her cheeks. She turned her head
and exhaled and we said nothing but quiet.
The squirrel in the laurel paid us no heed
nor did the Sorko girl huffing to make mass,
her shiny scarf fluttering behind to catch up.
When she finally spoke in rich tulip Dutch,
I had no choice but to turn myself over for her.
When she curled a lip, I heard "Take me home."
I slid my left hand into the deep loose loam,
let my roots tangle and slide lovely with hers.
My lids turn petal silk and she my eye blue.

This Moment of Fruit

Under the fig tree Shelton Knell planted
in 1946 after carrying it in his scarred rucksack,
a gift from Ava Maria Cantintelli for saving
her parent's home from a German hand,

I look from the hill onto the bronze Allegheny,
the summer sun so sticky rich in the humid breeze
and understand the firm love given to this tree
to have it take root and survive our Pittsburgh.

Fig covers me with her shade, and Ava Maria,
surely in the ground next to her parents,
lays hands to me. I open trembling thick sweet.
The bee that lights to my arm sings of wine and desire.

Somewhere in Tuscany, a grey son knows why
all I can do is not move from this moment of fruit.

SEE RIGHT

Before I could stand, I sat back in my chair.

Had you seen the low September clouds
hold the city softly this dawn in wet gray
while the sun pushed between red and yellow,
the neon lights tickling the bridge piers slipped
with the smooth quiet river slate waiting waiting
for nothing but sun's long spill yawn to open a clear
lane for the towboat to find strong tie to dock,
the crew to part into the morning mist shroud,
bag-eyed, to finally drift free their long ways
to the lock, the open door, and just maybe
the kiss of bacon and the splash of love?

It is easy to pick the rose when obvious,
it's another matter to see right what's there.

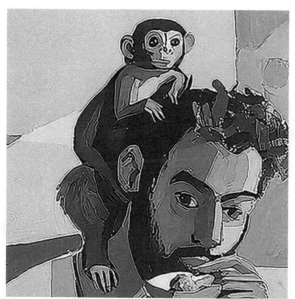
NOTHING IN HEAVEN

The Aluminum Awning

Not three miles from here my father's two-tone coffin
nuzzles the hug of dirt the temperature of a wine cellar.
We sent him on his journey with letters and coins
and a blazing red felt cardinal. Even with that,
no one could take his place.

Down the garden hill,
across the red-brick street
over the abandoned trolley tracks
beneath a vigilant aluminum awning
clinging to a now dilapidated rental property,
half in cover, half not,
an abandoned tennis shoe curls its scuffed toe.

Tomorrow or the next it might again
disappear into some other hubbub.
But awakened, this rag-tongue oracle
welcomes its brief opportunity to converse.

I touch my left foot as inconspicuously
as his thumb brushed mine
seventeen hours before the phone rang
and blinding magic erupted from glasses,
and radios, and clocks, and photographs.
The flesh rages with a light so overwhelming
it's invisible.

I found a partly written novel in his locked trunk.
I keep his tailored gaberdine overcoat in my closet.
Grandma Stubinger taught me to tie a double knot
when it still made sense to drop daddy longlegs
into the late July vacation campfire coals.
My sins of brutishness and arrogance decry my debt.

All Get Wet

I have my coffee, but the chilly scarf
breeze damp round my neck won't sit
still, and I curl my toes in grubby slippers
to hold myself firm in the mesh porch chair
while a mole makes daring way from wall
to hosta cover without the cat's cold notice.

Bells ring from the last church on Dinsmore.
Pastor Newman tugs the braided oiled cable
calling a sown flock to touch hearts kindly
and sup the spirit the round sound reveals.

Hermes guides blind widow Mrs. Lessing
on their ritual morning walk, she waves blessings.
"Hello," I call and what she said back is lost
in the startle of a milk truck grinding gears.

There will be no sun today, only heavy gray,
clouds drizzle this majesty for all to get wet.

April 5, 2020 Palm Sunday

Daffodil has had all she can stand of our dark.
She's had enough of me waiting to know her.

She chucks my socks atop the tulip's head,
slides my toes along her stirred root tangle.

She wants me to live her press push bulb.
She wants me to kiss her, sway her back.

She wants me to smear her pollen wild.
She wants quiver buzz bees between our lips.

She wants me sticky stiff abandoned wild.
She wants my ears to petal, my tongue to split.

She wants me to yellow. She wants me to bloom.
She wants me to curl and slip, to stem with her.

She wants me to wet dirt twist dance spring sky high.
She wants me to daffodil. She wants me to Christ.

Imprisoned Hearts

The sun had some kind of storm. The neighborhood was out on our Saturday night's cool May spring porches looking to the heavens, or at least across the valley, to see the sky speak in colors and to say, to those who hadn't, that we saw what we might never see again, even though we would have seen it better without the street light or Adam's halogen yard lamp that incinerates anything smaller than a quarter suckered within two feet of its buttery claim.

The lights we saw were mostly reds and violets. For maybe a half-hour, we were tangled wet in the sky shower that danced a dance that silenced the insolence that had us barely wave to one another otherwise.

Edie Moses texted us about 10 p.m. from Blawnox, up the Allegheny, and said they had some greens and blues shimmy over their hills, that the Church of the Imprisoned Heart was ringing its bells and she could hear someone praying "Amazing Grace" on a saxophone from the park gazebo. Dot, who rarely says much of anything that we catch, yelled to Nanc, "Well, isn't that something?"

• • •

In Nepal, half a day earlier, Priyanka took to her blue scooter to gather Pooja in front of the heavy, old-wood matte-yellow door of her family home. Her grandmother, silent on the veranda with a tea, extinguished the candle to respect the sky's moment and Pooja's release beyond the lanterns and laughter.

Through the slender streets of sky-eyed Birgunj, they lean and twist. Pooja's arms wound Priyanka's soft waist, her right warm wrist found home across the bellybutton, the loose top of Priyanka's peach cotton top, which in the breeze teased the knuckles of Pooja's left, both their breaths skipping beats.

The torch of Priyanka's bike led them at last to the edge of the Sirsiya. It was only them and the river's quiet cradle. There they shook off their helmets and sat in the spring grass just off the shore touching, the rhapsody of sky thumbed color across their faces more delicate and deep than they dared dare smear over one another's yearning during Holi. Pooja tilted Priyanka's waiting

chin to her, their masks removed. The mountains cup the mist, heaven's pigment theirs, and there they disappeared in this now forever. The Goddess Ushas found them in a first-time kiss.

• • •

It was 1967 or '68. Hideous Harry walked by the stoop of our ruddy Insulbrick house, carrying bags of what we had always imagined were things horrible and not to be known. Harry never spoke and kept his head down. No matter how straight-line he remained, the taunts could not have bounced off him. Harry was raggedy and string-haired and lived, everyone assumed, in the woods at the end of the street before the cliff that fell to Route 51 and the near-poisoned creek.

My mother said, "Good morning, Harry." "Good morning, Mrs. Lehner," Harry returned, not breaking stride. He then did stop. Hideous Harry turned, stepped back, and handed me a magnifying glass and a box of crayons from his rundown purple bag, and went on his way. I burned many an ant with that glass. The colors carved into the walk took longer to understand.

To Hang and Home

My ghosts like your ghosts wave and mingle.
They chatter. Some on the porch, some on the hill,
some at the dining room table, and the helpful ones
in the kitchen when I mix my spices and meats.

The man in the battery wheelchair hums just there
with a grey German shepherd raises his palm to me.
The old buff Chevy out for a Sunday stroll clutches and yields.
The ghosts near the street dip their heads and match pipes.

The vines are turning, and the Halloween spooks and bones
find their way from attics and wraps to windows and rails.

We have our tall skeleton buddy who loves this time of his.
He plops and teeters hips on the glider and wears his beanie.
O', his eyes light red, his jaw falls slack with a warm teeth smile
the crow remembers. Crow adores him with tinfoil and stones.

The cat wary of the whole deal camouflages under the low pine.
The spider turns her flag to the breeze and the dancy dew jewels
night work worthy of sparkle and bead. I've little left to give.

In a few weeks I'll wear my mask and scarf and sit on the steps,
lift my cane basket of treats for tyke and teen and live right there
knowing our dead are as happy to play as they are to hang and
 home.

No Saint Will Relieve Me

The cardinal hopped hard onto the cat's head in a fit of faith to
 proclaim the tree birds',
then duly dispatched tabby into the black-eyed Susans'
 browned, stubborn winter arms.
While this feat left the starlings and the chickadees relieved, for
 now their beaks safe for seed,
it did nothing to lighten the twist and hitch that kept Mr. Shelton from enjoying his walk.
It's five below, yet there he is, waving to me in the window,
 giving me a double thumbs up.
This quiet snapped by Billy scraping a bouncy red plow blade
 up the street, tooting his horn,
spinning salt from his rear, hell-bent to dispatch the soft cover
 snow had made Sunday pretty.

• • •

When I was twenty-two, I worked a bit in a state institution for
 the forsaken and forgotten.
And no, I've never been near war or lost in some cataclysm
 more than my cake-ass doubts.
Here, boys and young men of feeble minds, feral smells, and the
 bright, wet eyes of now
swirled and scampered and, in some semblance of clothing or
 not, sang in private languages
that hauled me to the mop-dirty floor to flop in their aquarium
 of soft toast and cold mush.
There I sin, and I love. The sin no Saint will relieve me of. I beat
 poor twisted Gregory Burt.
The love. Ricky Berry, and his simple smile. Putting him in my
 Ford for the park and swings.
I had a couple cups of coffee, and I'm going to make a galette for
 the young couple leaving.
Would you still think so much of me if I told you more? It's the
 hurt inflicted that haunts.

For Naught

Paul Stranfratti eats cheese on the corner
while Edward Bestlenter walks Shrine

a cropped-tailed pooch that found way
to his backdoor by who knows just how.

Neither man waves to the other for reasons
neither can rightly tell but revolve around

something about Sharon Pyburzkyi 40 years
past when all had nothing but future to tell.

But that just went for naught for the future
took a detour around these parts and left

nothing but extra weight, ache, and bitter
light which stabs every ounce of joy dead.

Only during Night at the Races the boys hold
at the firehall do anything like smiles happen.

Cold beers and hot sausages remind all
their lungs take in this same barely moving

air until someone flips a look and they forget.
Then the dull intent of denying love returns.

First Day of Spring

I had a drill bit snap. Came up
short one #4 half-inch wood screw.
Forgot to mix the cooled butter
into the batter. Dropped a hammer
onto the outside of my right ankle.
The tube of caulk burst its side.
The utility knife bit my left thumb.
No apple galettes were made.
I think the cardinal laughed in my ear.
But there, the amaryllis sings her red.

It's Gonna Take a Miracle

This sky's not so grey.
Let it rain, it'll make no mind!
I'm dancing in the street.
I've the morning post in one
hand and a tea in the other.
The columbine's white blouse
bursts from her purple Sunday coat.
Mrs. Meshell gives a sneaky-peek
from betwixt her curtains trying
desperately not to be seen. I wave
for her to come join me. Come,
come join me. I'm here, yes
on the red bricks, my bare
feet sliding though the pine's
sawdust pollen. My tap dance
for joy. My shuffle in hope.
My resurrection from darkness.
My illumination before the azalea
burning red, red, red. My ecstasy,
another day with the cardinal,
one more hour with the squirrel.
My miracle in song. My miracle
under the sky. My rich miracle
of dark earth where I can be with you.

COFFEE AND CHRIST
To Marianne Leister

For two weeks I've been catching the same mouse.
She pink-foots her way to the corner for her bite,

the trap door claps, and she whistles and dances.
She prefers yellow English sharp to Dutch gouda.

I put on my slippers and take her, in the morning,
to Sorko's garage and set her amongst the Madonnas.

After dinner, she goes to the thicket of broken stones.
She big-brown-eyes me then shows me her thin tail.

I wave to Mrs. Meshell who stands in her window,
she's not been the same since her Heaven fell dead.

Three deer wait in the garden for apples and pumpkin.
Cardinal hankers for sunflower seeds. Squirrel, walnuts.

It's cold, I should have a coat, but that seems just wrong.
I should invite mouse in and offer her a matchbox bed.

I should lie on the floor, let her curl herself in my hand,
click my teeth and twiggle tongue and sing my mouse song.

I reckon mouse is a patient angel I'm too thick to see.
I sit in this damned green chair, a stupid bald wise man.

Up and down, in and out, day after day for two weeks,
the whole time sharing coffee and wine with Christ.

The Particulars of Rapture

Doug turned up with a sweet magnolia a lady in Sewickley was done with and with which the deer had their way, so we stirred the earth on a too-hot late Friday afternoon that announced the Memorial Day weekend was at hand. The patient green and the flowers danced in the soft swelter and rejoice of their winter release. Men talk when they work. Some about solving the problem. Some about cursing the stones and clay. Some about whatever. During a blow, Doug showed me a photo of an Imperial Moth. This was outside of Uniontown, where his mom still carries on. The moth is the full size of a child's face. It's furry and luscious. Moth hides as a leaf, which the birds still find. It lives a week. Which led to how do Monarchs migrate? A "How the hell can they do that?" Which led to what we don't understand. So, we finished our job, had a cold drink, and shook hands.

• • •

The cemetery was full of fresh flags. Dad looked a bit shabby; the birds had had their way with the stone. The Saturday late-morning sun had just turned from warm to fiery. With scrub brush and small mattock, Pop's granite cleaned up and the plot freed of the claw of weed and carpet grass. I lounged, cooling wet with sweat. A colossal oak held the blue big-cloud sky, and the crows cawed. Dad reached and hugged me, pulled himself from the loam, and sat with me. Today, he wore his Navy whites. He asked about his cardinals and squirrels. He said I looked good. He held my hand. He was young. He tugged me, and we stood. I straighten the flag on Mr. Kostelnic's grave. Dad waved him on, and he came; he was Army. People were kneeling and digging, planting and praying. Kids running. Their picnic of wreaths and sodas. Music bubbled from someone's car. And the land filled with men rose up to stand. Some full. Some missing something. Some in pieces. But here, we are. Here, they danced. Here, they were held. Here, they loved. Their wives. Their children. Those gone before that joy held the little ones who ran to them without fear with candy and kisses.

By the Hand of My Tongue

When I saw the lost hummingbird quick kissing the hairy
 sunflower harvest proud
and I witnessed the thick apple farmer open a tart Anna Maria
 with his worn Barlow
and when the two Greeks offered me a handful of gyro meat
 and a round bread
I knew my achy knee and my twisted right thumb had earned
 this moment of song,
that my blind falls and crawls of bright eyes and open hands
 seem less slaphappy.

And I knew the 9 a.m. sun knew nothing of the Hunter's Moon
 and knows little of me.
I knew some murmuring stirring dirt waiting knew I am hers to
 steep and chew.
I knew that I was flesh drenched and the bag bounty overflow
 on my shoulder
knew well the twenty dogs and the hand holders and the coffee
 drinkers and tykes.

When Mary Mike appeared, and we sparked hellos, and when
 she and Nanc and I
cupped fingers and twirled and sang song of paella and ruby
 greens and pink beans,
of cornbread and salt butter, of ferment and cheese, of black
 chocolate and amber jam,
I knew those clapping and chuckling with their blooms and
 plenty in tow knew
hands had turned seed to fruit and fruit sweet turned tongues to
 tune and tune
to welcome and welcome to joy that curled and tangled through
 cool October air
and I knew Bârü waits behind the door more certain than to-
 morrow comes hither.

And I knew the fists I raised in anger and punch would please
 forgive me, or not.

From the Grave to Touch Again

My father sits on his headstone and breathes quiet;
he was always partial to spring and catching ball.
Dad's flag tilts slightly to the left, he leaves it be.
War breaks a man in ways that often heal crooked.

My hand peacefully aches from foul tips and punches,
a boy galloping in a wool uniform and dusty spikes,
sportsmanship a balm for a father to teach his son.

I knew nothing of the South Pacific or his mate
who vanished in the torpedo twisted and torn aft.
Two seventeen-year-olds pinch a can of peanuts
make way to safe shade beneath a gun turret
talking about nothing much when the alarm sounds.
That tin waits unwearyingly to share its salty gift.

I've left both doors open. He'll visit later, I know.
He has been too quiet. The comfy chair's on the porch.
My view looks over the ocean of a Pennsylvania valley.
Its slope cedes to the Ohio and the bone-deep tugboat horns
that roll back up the steep hill to pull a dead ear to life.

I'm going to work in the yard with my shears and gloves.
I'll leave Dad his space to make way inside to Mom.
He'll lift her from the shelf, and they'll sit and lunch
in the green leather recliner. He'll hand her a love note.

I found fragments in his belongings before he set sail.
A match pack from a music club, a streetcar token,
a machine photo-portrait of a woman with wide eyes.

We make way, boxing what might have been otherwise.
What's given we return from the grave to touch again.

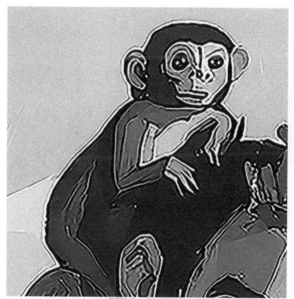

MRS. NUSSBAUM'S MONKEY

Our Parade

There is a dog howling. There is a pigeon cooing.
It is raining, but of no mind to these fellows pinched
into uniforms from when they were only old enough
to imagine a future of endless dancing and dream kisses.

A lot of dam has passed under the bridge since then.
They are trying to make sense of their stiff legs.
They are forming up. There is one Marine, the rest
are Army, and they're having their way with him.

Sixty years of work and houses and children and loss
melt in smiles so huge I sit in my fold-out chair clapping.

Twenty guys determined to march again, to march
along Bradford Avenue, five blocks to the Borough Building,
their modest goal, the granite monument with the granite globe
and the granite base with the bronze plaque mostly forgotten,
mostly invisible. Sergeant Chiarini carries a folded flag.
Lieutenant Provelnski lost his light and his corner stool
at the VFW where his cap and metals and his watch wait.

Later, they'll set him up a beer, but now they carry him
as best they can. Shoulders square, ten rows of two.
The Boy Scout band—three drums, clarinet, and saxophone—
plays some mangled version of "America the Beautiful."

The world begins to turn, and their old boots begin to move.
The doors open, and the good people of Crafton
emerge with cakes and pastries and sticky breads,
join the procession, huddling close, abandoning
their TVs and their daily ambitions and come forth
alive in poverty. Home, at least for a bit, tangled
amongst the red bricks and fire trucks and noise jubilee,
shoulders touching when the guns salute, and Taps is played.

Sweet Jesus, what have we done to ourselves?

In Pittsburghia

The two children crawling over the crab apple tree
do not understand the silver watch with the blue logo
sitting atop the television. The Iron City
sweating in their father's hand is not new
nor even the pigeon's gnawing "coo," backnoising
his breathing feet resting atop the coffee table.
In fact, nothing has changed obviously.
The alley is still full of junk.
The neighbor lady bitches at the papergirl for landing her paper
in a spring puddle. The dog walks in a circle.
The inbred family scream at one another about nothing.
The restaurant parking lot is empty.
The regular mailman is on vacation,
unlike the father that the children take for granted,
who is uncertain what it means to be clean at 10 a.m.

Mirabile Dictu

There's a sparrow on the head of Groucho Marx.
It's just me and the dog and the sock toy and the window.
He's sprawled with his snout atop his rag friend.
Groucho's in the garden. His mustache a little faded.
His aluminum-pole body a little twisted.
It's February 20. The bulbs peek from beneath the mulch.
The old Italian hoses down his siding. The grass is matted.
There's a bald whitewall in the brush beyond the rusted fence.
A cat paws the last piece of winter ice hidden there.
You're in Pittsburgh again. You're having your coffee.
You're one block from the grand view of the city.
You're three blocks from the incline. You're at the window,
wavy and dirty. The squirrel emerges and the sparrow leaves.
There are three ponds—Miller's Ponds—in Wooster, Ohio.
On days like today, the hockey players gone, the ducks take
 their brown bodies
and flat bills and splash the water above the carp and reclaim
 what's theirs.
The dog's unconcerned about such things. And no one really cares
whether we get up and go have some breakfast. It's Saturday.

IT'S LIKE GIVING DIRECTIONS IN PITTSBURGH

Go down this street here, two lights.
Make a left and go straight to where
the old Dairy Queen used to be.
Make a right there and you'll see
a gas station on your right
about three blocks up the street.
Don't turn there, but go straight
for about a mile to where the road Ys.
Bear left at the Y. Go straight until you see
a triangle-shaped yard that's full
of lawn balls. One street after that
make a right and go another mile
or so—you should see a railroad trestle
on your left. Don't turn there, go past that.
Keep going until you get to a corner
with a huckster's stand.
If you come to an abandoned milk factory
you've gone too far. At the huckster's
stand make a left. If they're open
you should buy some fruit, they have
the best peaches. Make a left at the huckster
and be careful, the road there gets a little tricky
because it's been torn up for a long time,
there are large steel plates everywhere.
Go on that road, oh, about three miles.
You're almost there. When the street gets better
you'll be on cobblestones, watch for
a blinking school sign that doesn't work.
Make a left at the sign and a quick left
on the next street. It doesn't have a street sign.
Go two blocks, you'll see a big orange house.
Go ten houses past that and you'll see
a house that's not yellow. I'll be sitting
on the steps with two cups of coffee
and a handful of flowers when you get here.

Canvas Flaps

How might the lad's path have opened otherwise
hadn't the camp master shuttered the canvas flaps
and touched what was never his to touch and take?

Maybe lad would have cared less about the yard hawk
with a shattered wing taken into a homemade sanctuary.
Maybe he would have never learned to catch those mice.

Maybe lad would have slung rocks and bottles more gently
and lain under the table to read the carved signs and names?
Maybe he'd have mouthed her name in another timbre when
 they kissed?

Maybe lad would have not learned to brine and can tomorrow
and stow chewed pencils in the hidey-holes in the attic floor.
Maybe he would not have, but he did, and that's the sky blue.

Not to Know

There is the dog. There is the crow.
And I remember my smug ugliness.
This was a long time ago in the days
of assassinations and the city burnings.
And it was a year or so before our riots
and the chaining of the school and we mixed
on the ballfield and laughed in the warm spring
sun crack-smashing balls and cleat-kicking dust
and sitting in the nub grass just guys home away
from that street or this or this noise or that
and we tossed our gloves to the wood bench
with wet mutt noses, flock wings folded,
ladled steel water bucket, and some candy bars
knowing what we were supposed not to know
but we did before we went back and were told otherwise.

Treats We Shared

Mrs. Martini had one eye that she never failed to say she lost in the war plant. And Mr. Rectenwald, who drove the Sealtest milk truck, had two fingers missing, stubs in the middle of his left hand that had something to do with the U.S. Navy and depth charges in the Pacific. This was well before Jim Slater and Harry Welton went off to Vietnam and never came home, flags and stones in Arlington. I saw them on the Wall before the deep part.

Mrs. Martini lived in a tan-stone corner house, Mr. Rectenwald on the next block, a wrap-around-porch home that held eight kids. The Slaters two doors beyond in a '40s red-brick with stained glass and a one-car garage. And the Weltons at the end of the street, broken, dark, deep gray, and falling in on itself.

But time is mixed up, and that's a lot of war for one narrow street that held me. It's nearly 11 a.m. on a Sunday in November. Thanksgiving's in four days, and the bells ring at St. Mary's and the United Church of Christ on opposite corners of Shaler Street. They sound out of sync as they have done for most of my life, except for the seven years when somebody silenced them because the clang and dong messed up the night shift millworkers from falling into sleep. But that got put finally to rest by I don't know who.

Most of all the fathers of Augusta Street, and Duquesne Heights, and Mount Washington and up and down the three rivers of Pittsburgh are deep in the dirt, taken with them the wars and the lost parts that live through what was made and left on these streets. Mrs. Martini and the blue screen door opening onto an orange terracotta tile porch, a tray of cookies or cakes, something cold to drink, and her German Shepherd, Kingy, with a green crucifix that swung from his leather collar and loved the treats we shared.

Penny's Testament

I invited the Jehovah's Witnesses to the table
for a bit of lunch and lemonade and iced tea.
Jennis and Theo had come dutifully three days
in a row and trudged the thirty-seven steps
to the front door, stiff, smiles wax-perfect,
to present the Holy Spirit to louts like me.

"Can we just sit and play Parcheesi or Clue?"

Jennis, fond of the mozzarella and prosciutto.
Theo taken by a wrinkled striped napkin asked
how I swayed jays to sit in row on the brick sill
anticipating peanuts and fat and whistles of love?

I bared a penny come upon in the basement drain,
pitted and patinaed, and rubbed Penny lovingly,
fitted her in my one eye, and set her tender before
the clipped lass and lad and offer them to have her,
for a pocket or purse or mantle, a wild witness,
a totem, a round of jazz, a hallelujah, a copper kiss,
the tie and the bonnet severed, feet bared to garden grass,
a sweating glass to the lips, the sandwich's first bite,

unhidden as Penny, waiting since at least 1971
under the pock-metal grate, not fallen to the trap,
patient and certain a happenstance hand would arrive,
tidy her face then be love-twisted, Penny's testament,
as we collect here forgetting finally every other thing
but full plates, table laughs, and strangers found.

Confession

It was me, yes, who pinched Eisler's dog, Buster. I did so on my first return to my college dorm after Thanksgiving. Buster of ten-foot chain, worn dirt circle, and lonely smidgen house, sprang without pause into the front seat of my cool blue El Camino.

And good boy who I years friended, with sit, ear scratch and chipped ham, Rt. 30 head for Ohio—the better tomorrow I promised would unfold, as had had for me who found himself round-eyed and wonder lost in fingers and lips, and tangles of hay hair of a taut tan Mennonite girl who wisp to campus to dance with a change of clothes and breathe.

My lord, Ohio in fall, window-open before the stiff winter stalks, in love, parked under a bumpy oak, on a farm hill with cows and two-tone sheep, a pattern sewn blanket, and steak sandwiches and bottle beer and nothing but time to keep Buster from his now of sprint, circle flips and sleep plunge.

I clutch after the brown horse that stepped her bonnet smile to the Smithton grocery.

Buster's ghost keeps my toes warm. Occasionally, he notes, she still now traces the ball-point drawings laid over my arm then. And he again asks me to forgive my wrongs. The El Camino I sold cheap to her little brother still runs and is said a sight to be seen. I've no idea if Buster shares anything he knows of my many hopes but maybe he does.

IN THE TIME WHEN NOTHING IS SAID

I remember sitting near Dover before leaving. I was smoking. An orchid moon tipping her lips over the stomach of the sea gave me what I needed to up and go. I can't forget the damp my wool pants pulled in. And I can't forget that I jumped from a jeep and found you under a sky a blue my pen had no way to feel to words. It was one of those times when it's time for time to change. You wore your hair back. Your dress to your calves. Your button one button open. Our eyes caught then, too. It was that time that now we know in this time when it's the time we part when the paths crook and you breathe the air there where you dance until the paths again cross and the walk tangles in hand and laugh. Your heels were black, and the floor was brown, and you danced then there too, and we found faces the sun shadowed on the sheets.

Nothing I know is any more certain than I know that I found you here again in a time when time might have us not notice what to do with what we've noticed. It came to me that we ran in Paris. That's when we sweat and swoon to Django Reinhard. That's where we drank until we had to sleep. You were drawing then, too. You were walking Rue François Miron when you said, now I must go. I will see you soon, said your kiss. You disappeared into the corner at Rue de Jouy, and we remembered that as we sat drinking coffee in a Friday winter sun, reading books in the time when nothing is said.

Draft Letter to Nancy Koerbel's Poetry Class Who Found Me Before Them as a Substitute Teacher, Wednesday, February 7, 2024

I don't believe any of us paused to realize or recognize we were
 in a cathedral
of learning, or on this downright springish blue bright February
 Wednesday,
what was still unimagined in the tallest educational building in
 North America.

Nor, I suspect, any of you, spread out brilliant clumps of crocuses
 and daffodils,
peeking at me wary, one eye blinky and the other matte flat to
 your desks and devices,
get that *The Cathedral* was built, in part, with Mercury dimes
 collected from school children.

Silver dimes, long before your times, and before Selma Hortense
 Burke arrived in Pittsburgh
to share her Harlem Renaissance bounce and burn, before money
 bulldozed her Art Center,
but not before her silver-brown hand held mine. I want you to
 know, I carry her forever.

This Roosevelt dime she designed (do you still use coins?) I give
 you for your palm to grip,
as she gave me—a knucklehead city boy—some courage to look
 for his two cents to say.

Say, but here I am with you today. A coincidence? A trick of
 fate? A blessing? A bore?
And I throw my line out into the dark lake of your early wonder
 to see who there might bite.
And lord, the pond is right-full with wriggles and leaps and
 splashes. There you are
up, through the surface, crazy, air bound, shiny, if only for a
 few seconds, free and playful.

And maybe we all rise like this from one world to taste another.
 And do swim some more
before we find that bolt, that dare, a kamikaze, Geronimo, o'-
 hell-yeah leap go-thrill of now,
which we found silly, a warm wet mud we sassily slathered
 across one another's faces.

And it was not Ross Gay so much. It was Mahitha and her ban-
 gles and eyes pounding joy
that toss and splay the chairs, sprung the windows, and there
 we were, wild and dancing.

I'll catch your names next time—who cares!—for now we're all
 feral smiles and flying hair.
A time when there was no time, even for the slimmest moments
 of time there we were!
Joy laughing. Joy bursting. Joy tangle. Joy frank. Joy joying joy.
 Joy you. Joy me.
We joy moment. We joy stones and arches. We joy floors. No
 stuffy European cathedral
has any joy on us, none. We joy like no one else has joyed. We
 poem joy. We dime joy.
We scar joy. We fear joy. We broken joy. We future joy. We joy
 we don't know we joy.
We tomorrow joy. We death joy. We worry-wort joy. We inse-
 cure joy. We flesh joy.
We joy constellations, pressing our joy light out where some
 student stumble-bums into a class
lifts a head bright and snaps up a hand and interrupts the pro-
 fessor and stands and claps joy.
We joyed that. A joy that wouldn't have joyed until we joyed
 together before the bell rang.

Clay and Bricks

There's always the wonder and magic of Dock Ellis pitching his *no-no* on acid defying the Pharoah's gezera, and there is the fiery redemption of Franco Harris catching a ricocheted ball that today would have been reviewed and parsed from a hundred frame-by-frame angles, but that day of Exodus all anyone knew was Franco galloped down the sideline carrying our Torah and Pittsburgh's forty-year exile from any Promised Land was lifted.

There are scar days. Scars that keep me in the wilderness. The day I kicked the dog. The day I defiled Sheryl Cantor's dignity with my ugly taunts. The day we drove to Columbus in a '72 Super Sport and learned to use chopsticks. The day I carried my grandmother to the grave. The day I buried a message in a tin box. Even at ten, wanting to leave some sign or signal that someone was here before them, and here's what I had to offer: a pencil, a baseball card, a nickel, a crayon self-portrait, and a note—"I hope you find this, and you are happy. My name is Frank. I have a parakeet named Pal. He bites but likes to sing."

On the Monday after the Sunday Franco, our smoky God of desire fled the Tabernacle, and every car along every street of Pittsburgh disappeared, the men off to the mills and toil of the week. They build for the Pharaohs. They build with clay and bricks made of their bones.

The mills are long gone. Franco and Dock live in the Seders of beers and barbecues and tender knees. The old hold grandchildren, kiss their cheeks and glide a finger to free their lips to speak what their heavy tongues feared. God, hear the cries of the strangled, those wedged into the walls. The dead we owe the *no-no*. The dead we dance the sideline and Franco. The dead peek from the mirrors the wives hold and tease before their fatigued, flaccid men and say, "I am more beautiful than you." The dead gave rise to me. The dead sit on our porches. The dead save our dollars. The dead tend our gardens. The dead praise our children. The dead jolt from our seats and possess in a finger snap everything we might ever love and lose.

Jimmy Psihoulis' accordion doctored the Pennsylvania Polka. Stand and sing and weep. O' Joy! "We are the town with the Super Bowl team." God knows it's for the sake of the neighborhood no Golden Calf can satisfy.

Mrs. Nussbaum's Monkey

I don't know why Mrs. Nussbaum had a monkey, but she did. She lived in a one-story white brick house with a mammoth picture window with a drape rarely drawn. That open space was a magnet for all who passed to gawk, and there they saw in the dining room the silver cage and the longtail monkey, Jessers, who was like Mr. Longo's Dachshund and the Hoffmans' bunnies. Jessers, after the morning sun pushed south over the roofs, would be on the porch between two painted rocking chairs—the rails of his confines almost invisible—face the street, cheep, and reach out looking for a hand.

Jessers had a thin head, a long nose like Jimmy Durante, and light green eyes with blackish circles. He was the size of a football. He looked like a little monkey person, like everyone else, and was a little something one way or the other. Jessers was mostly grumpy, and for all the want to have Jessers as a chum, he'd claw the hand who dared touch his leathery fingers, and the little gentlemen bit me once too often. But we tried.

Jessers was also a sneaky fellow, and Mrs. Nussbaum's eye not so watchful. So, it was not unusual for Jessers to be up the telephone pole or sitting on the roof of a car or monkey walking down Augusta Street, maybe to head to the five-hundred block to pinch some eggs from the Minskers' chickens or cut through the backyards to Edith Street and O'Connors' fountain and the flock of goldfish they kept. Jessers was decidedly less grumpy when he was out and about, and for the most part, Jessers hung out while we played and talked kid stuff until, somehow, he went home to his cage and the lure of imported fruit, kind of the way we all went home when the streetlights came on. If something was missing, a toy or a tool, the first thing you did was head up to Nussbaums' to see if the thieving Jessers had pinched what was missing. Jessers was still there when I left for college. This is background.

• • •

I guess this was an evening when Jessers couldn't sleep or was rambunctious, or Mrs. Nussbaum had one too many highballs. I slept in the third-floor attic, but our house was paper-thin, and

I could hear talking. No one was ever up this late in our house. But I heard talk and cheep. So, I headed downstairs, tippy-toe quiet, desperate not to have a stair squeak, to the kitchen in my pajamas and bare feet. There's my father in his chair, a two-tone '50s Formica, chrome-legged table, and Jessers on the back of the chair facing the stove. Pops has laid out a little spread of Velveeta cheese, sweet pickles, and Saltines. He's opened a stubby bottle of pilsner and poured Jessers a little piece. Pops never said much, but there he was in his T-shirt and loose boxers telling Jessers about the Easter Tuesday night he lost his mother and taking the streetcar to go to work because there was nothing to do until the next day, and the plant owner only gave two days off for deaths.

I recognized the voice, and it was like that voice that told me stories of playing ball, or how to thread a worm on a hook, or how to hold a soldering iron at the angle just to kiss the flux and let the metal hug the wire. I sat on the bottom step, out of sight, and listened. Jessers breathed and cawed and growled rumbles from his tiny heart. Jessers liked the cheese. This same combination, sans the beer for me, Dad and I ate after coming home from the Saturday night hockey games and sitting down to watch Chiller Theater and the monsters and sci-fi flicks of life run amok in some way or other. Where man and beast rarely found table and conversation.

Maybe I missed Jessers' story of transit from Zanzibar or New Guinea and his Ma roiling in despair, her little monkey gone, and her spirit flattened. I'm not sure who teared up first, but I dare peek around the threshold, and Jessers is holding Dad's first two fingers and thumb. Jesser's eyes are wet, and Dad's left hand is wiping an eye. Two men alone, together, and safe before the lights come on and all that's expected with that. I have loved Jessers from that moment until now. Dad gave Jessers a scratch on the head and a nod. Jessers monkeyed up Dad's arm and out the window. "Come on, Frankie. That's enough for the night. Time for bed." His hand on my crewcut head. The plate empty.

It Made Me Cry

I rang my buddy Rippin to catch up.
I've known him for some forty years.
Chrisi O'Neil and I blew him up once,
two cigarette loads in The Cathedral of
Learning, the early '80s. He was teaching
Plath. I wore a leather bomber's jacket,
flitted with Frank O'Hara, mooning bad
over Cynthia Genser and our Pittsburgh
nights when you could take a few beers
to the three brick stacks of the rolling mill
watch mist fire red and yellow and swirl
there on the hood of Hörff's blue Pontiac.
He soon went many-voice mad, and Rogue
fell, first to the Rosicrucians and now horribly
blind to Trump and a Christ of Hate, snapping,
when we last spoke, "I love you, my brother.
"You are headed to Hell eternal; I'll pray for you."
Kevin answered, and we picked up as we do.
"Uncs," he cheered, "I wrote a poem last night
so beautiful that it made me cry." I could hear
a tear in his voice, and whispered, "I understand."

Notes

Epigraph
Yinzer is a term to describe someone from Pittsburgh or Western Pennsylvania. A yinzer has been immersed and raised in the culture, understands the tradition, and speaks the distinctive dialect of Western Pennsylvania—Pittsburghese. Yinz means "you" or "you all", singular or plural. Technically it's a second person plural pronoun. Yinzer Cred (a term coined by Nancy Koerbel while reading a manuscript by a Western Pennsylvania writer) is something someone carries, possesses, and expresses when living the culture authentically.

To Come Unsatisfy
Marc Harshman (1950–): A published, children's author, as well as poet, and had been the Poet Laureate of West Virginia since 2012.

Cave Tease
The 40 Mt. Washington was the electric-powered rail trolly that serviced Duquesne Heights and Mount Washington. The route ran across the mane of the hill and stopped and began at the South Hills Rail Junction (The Junction) for transfer into the city or the to the southern neighborhoods. (Also see "It Slide By Slowly" and "Not Giving Up".)

Small Bites
Loukoumades: Fried Greek honey puffs. Its origins date back to the first Olympic Games and were offered as honey tokens. The name is derived from the Arabic word *luqma*, which means "small bite."

Small Picnic
Timothy (Tim) Russell (1951–1922): Poet and writer who lived in Toronto, Ohio. I met Tim in Pittsburgh while he was enrolled in the graduate writing program at the University of Pittsburgh. Tim's works are American treasures. See his chapbooks *The Possibility of Turning to Salt* (1987), *In Dubio* (1988), *What We Don't Know Hurts* (1995), and *In Lacrimae* (1997). His full-length books are: *Advesaria* (1993) and the posthumous collection, *In Plena Vita—The Full Life: The Collect Poems* (Bottom Dog Press, 2023).

ALL THAT FORWARD
JOHN REPP (1952–): A widely published poet, fiction writer, essayist, and teacher. Originally from the Pinelands of New Jersey. I met John when he was in the graduate writing program at the University of Pittsburgh.

IMPRISONED HEARTS
BIRGUNJ: A metropolitan city in southern Nepal on the border of India. As an entry point to Nepal, Birganj is known as the Gateway of Nepal.

GODDESS USHAS: The Hindu goddess of dawn. Ushas is also known as the "life of all life and "breath of all breaths" who awakens all living beings and drives away the darkness of night. Ushas is sometimes depicted as the genius of poetry and song.

COFFEE AND CHRIST
MARIANNE LEISTER: Simply put, Marianne is a saint. I was a colleague with Marianne at Duquesne University's School of Leadership and Professional Advancement. Marianne's touch, spirit, compassion, and leadership have guided hundreds of students of all flavors to build better worlds for themselves and their families. She is also a fan of my madeleines.

CLAY AND BRICKS
DOCK ELLIS (1945–2008): A Pittsburgh Pirates pitcher who, on June 12, 1970, threw a no-hitter against the San Diego Padres while "high" on LSD. A no-hitter is known as a *no-no* (no runs, no hits). Dock, let's say, pushed the norms of the time when they needed pushing. If intrigued, see *No No: A Documentary* by Jeffery Radice or *Dock Ellis in the Country of Baseball* by Donald Hall.

A personal note: Dock, but mostly a woman friend of his, would come to the European Health Spa in downtown Pittsburgh, where I worked weekends as a parking attendant. Dock's car was a white Lincoln. In the glove box always lived a large bag of weed, to which we, with a wink and nod from Dock, helped ourselves without being greedy.

FRANCO HARRIS (1950–2022): A Pittsburgh Steelers running back. On December 23, 1973, the Pittsburgh Steelers, trailing 7-6 with

twenty-two seconds remaining in the game defeated the Oakland Raiders on a desperation, fourth-down play. A miracle occurred. Steelers rookie running back Franco Harris, makes a shoestring catch of a deflected ball and then gallops down the left sideline for the touchdown and the win. It's the first playoff win for the Steelers in forty years. The game was played in Pittsburgh's Three Rivers Stadium—this moment changed the course of Pittsburgh's history. The play is known as the Immaculate Reception

GEZERA: Is a rabbinical decree issued as a preventative measure "to meet the needs of the time." Gezera is used here as an uncompromising edict promulgated by the Pharoah. In a broader notion, the term means "the way it has to be, the existing order." The Pharoah's edicts were intended to force the Israelites into a sense of hopelessness and obedient compliance. My reference is to America's blue-collar world of the 1970s. For more clarity, precision, and expanse, see *The Particulars of Rapture* by Avivah Gottlieb Zornberg.

MRS. NUSSBAUM'S MONKEY
JIMMY DURANTE (1893–1980): An American comedian, actor, singer, and pianist. His distinctive gravelly speech, Lower East Side accent, comic language-butchery, jazz-influenced songs, and prominent nose helped make him one of the United States' most familiar and popular personalities of the 1920s through the 1970s.

ABOUT THE AUTHOR

FRANK LEHNER is a poet, award-winning book designer, folk artist, and playwright. Frank hails from and lives in Pittsburgh, Pennsylvania with his wife, the writer and educator, Nancy Koerbel, and their Husky mix, Mssr. Bârü.

He is the principal at Naridus, LLC. Frank holds a BA in creative writing from the University of Pittsburgh and a master's degree in psychology from Duquesne University.

The author is one of the founding members of the literary magazine *5 AM*. His chapbook *Some Kingdom* is published by GTA Press. Frank's poetry has appeared in diverse periodicals and his plays have been staged in Pittsburgh and New York City

Books by Bottom Dog
Working Lives Series

Mrs. Nussbaum's Monkey, Frank Lehner, 116 pgs., $17
In Velevet: New & Selected Poems 1995-2024, Jeanne Bryner, 202 pgs, $18
Wanted: Good Family: A Novel, Joseph G. Anthony, 212 pgs, $17
A Wounded Snake: A Novel, Joseph G. Anthony, 264 pgs, $18
Lake Effect: Poems, Laura Treacy Bentley, 108 pgs, $14
Smoke: Poems, Jeanne Bryner, 96 pgs, $16
Eclipse: Stories, Jeanne Bryner, 150 pgs, $16
Blind Horse: Poems, Jeanne Bryner, 100 pgs, $16
Cycling Through Columbine, J.R.W. Case, 264 pgs, $18
Brown Bottle: A Novel, Sheldon Lee Compton, 160 pgs, $17
No Pets: Stories, Jim Ray Daniels, 134 pgs, $16
Story Hour & Other Stories, Robert Flanagan, 104 pgs, $15
Salvatore & Maria, Finding Paradise, Paul L. Gentile, 247 pgs, $18
Earnest Occupations, Richard Hague, 200 pgs, $18
Learning How: Stories, Tales & Yarns, Richard Hague, 206 pgs, $16
A Small Room With Trouble on My Mind and Other Stories, Michael Henson, 160 pgs, $17
Pottery Town, Karen Kotrba, 130 pgs, $16
Beautiful Rust: Poems, Ken Meisel, 96 pgs
In Plena Vita- The Full Life: The Collected Poems of Timothy Russell, 280 pgs, $20
Waiting at the Dead End Diner: Poems, Rebecca Schumejda, 204 pgs, $17
The Free Farm: A Novel, Larry Smith, 306 pgs, $17
The Long River Home: A Novel, by Larry Smith, 230 pgs, cloth $22; paper $16
Mingo Town & Memories, Larry Smith, 94 pgs, $15
Milldust and Roses: Memoirs, Larry Smith, 149 pgs, $12
Beyond Rust: Novella & Stories, Larry Smith, 156 pgs
A River Remains: Poems, Larry Smith, 236 pgs,
Yeoman's Work: Poems, Garrett Stack, 92 pgs, $16
Drone String: Poems, Sherry Cook Stanforth, 92 pgs, $16
Choices: Three Novellas, Annabel Thomas, 180 pgs, $18
The Country Doctor's Wife: Memoirs, Cornelia Cattell Thompson, 166 pgs, $18
Voices From the Appalachian Coalfields, Mike Yarrow & Ruth Yarrow, Photos by Douglas Yarrow, 152 pgs, $17

Bottom Dog Press, Inc.
P.O. Box 425 /Huron, Ohio 44839
http://smithdocs.net

Books by Bottom Dog Press
Appalachian Writing Series

Labor Days, Labor Nights: More Stories, Larry D. Thacker, 208 pgs, $18
The Long Way Home, Ron Lands, 170 pgs, $18
40 Patchtown: A Novel, Damian Dressick, 184 pgs, $18
Mama's Song, P. Shaun Neal, 238 pgs, $18
Fissures and Other Stories, by Timothy Dodd, 152 pgs, $18
Old Brown, by Craig Paulenich, 92 pgs, $16
Sky Under the Roof: Poems, by Hilda Downer, 126 pgs, $16
Green-Silver and Silent: Poems, by Marc Harshman, 90 pgs, $16
The Homegoing: A Novel, by Michael Olin-Hitt, 180 pgs, $18
She Who Is Like a Mare: Poems of Mary Breckinridge and the Frontier Nursing Service, by Karen Kotrba, 96 pgs, $16
Broken Collar: A Novel, by Ron Mitchell, 234 pgs, $18
The Pattern Maker's Daughter: Poems, by Sandee Gertz Umbach, 90 pgs, $16
Sinners of Sanction County: Stories, by Charles Dodd White, 160 pgs, $17

Working Lives & Appalachian Writing Series Anthologies

Unbroken Circle: Stories of Cultural Diversity in the South,
Eds. Julia Watts and Larry Smith, 194 pgs, $18
Appalachia Now: Short Stories of Contemporary Appalachia,
Eds. Charles Dodd White and Larry Smith, 178 pgs, $18
Degrees of Elevation: Short Stories of Contemporary Appalachia,
Eds. Charles Dodd White and Page Seay, 186 pgs, $18
Appalachia Now: Short Stories of Contemporary Appalachia,
Eds. Charles Dodd White and Larry Smith, 178 pgs, $17
Working Hard for the Money: America's Working Poor in Stories, Poems and Photos, Eds. Mary E. Weems & Larry Smith, 204 pgs, $12
On the Clock: Contemporary Short Stories of Work,
Eds, Jeff Vande Zande & John Maday, 188 pgs, $15
Writing Work: Writers on Working-Class Writing,
Eds. David Shevin, Larry Smith, Janet Zandy, 220 pgs, $15

Free Shipping.
http://smithdocs.net

www.ingramcontent.com/pod-product-compliance
Lightning Source LLC
Chambersburg PA
CBHW021353250525
27212CB00001B/66